# Counter-Tourism The Handbook

## Assembled by Crab Man

ISBN: 978-1-908009-87-6

First published in this economical edition in 2012 by:
Triarchy Press
Station Offices, Axminster, Devon, EX13 5PF, UK

+44 (0)1297 631456
info@triarchypress.com
www.triarchypress.com

Designed by Imogen Charnley

# Contents

# Introduction

Welcome to counter-tourism. If you've ever been bored at a museum, gallery, stately home, ancient monument or heritage site, here's your chance to do something about it.

***Counter-Tourism: The Handbook*** will equip you with tactics and guiding principles to use on a personal journey through the heritage-tourism machine. You can pursue it as a gradual, three-stage progression from **tactics**, through **interventions** and on to **open infiltration**, or you can take it as all part of the same journey to be dipped into at any point; your own pick 'n' mix.

Just as counter-terrorism agents sneak among their enemies distracting them from their targets, you can prowl around the heritage industry as a counter-tourist, enjoying its mistakes and omissions, and gently mis-directing things in the interests of revelation.

Counter-tourism is all about tripping yourself up with pleasure and falling down the rabbit hole to discover places and experiences that the heritage industry conceals or ignores: buried ballrooms, accidental ironies, hidden histories, the 'spirit of the place' and the id of the site, mass graves and inconvenient details, the power of things and the fossils of the future. Heritage is wild, randy, dead and uncontrollable, but nobody's been saying so. Until now. Enjoy the tactics, begin the journey.

# Tactics for Counter-Tourists

## Talk to the sand

Choose a statue and start up a conversation. Confide, confess, discuss; find out what the past makes of you.

## Edgy

Rather than entering a heritage site, save yourself the entrance fee and explore round the edges.

Try to spend at least half of your heritage-visiting time outside rather than inside the official sites.

By walking the perimeter of a castle's grounds in Southern England, Andrew and I⊕ stumbled across the remnants of a US military hospital in the middle of a wood: a huge grid of rectangular foundations among the trees, with manholes and crumbling concrete roads. In one part of the ruins, we found a ceramic gulley that conjured up *X-Files* fantasies of mind-altering operations and gloop. Later we found a map in a self-published pamphlet about the hospital – we'd stumbled on the VD clinic.

---

⊕ The "I" here and throughout is me, Crab Man. As you'll see, the tactics and interventions in this book were tested and sometimes made up 'on the hoof' and I'm more than grateful to all those, not all of whom get a mention here, who came with me on counter-touristic forays.

## Flow

On your visits, experiment with walking at different speeds. At first, try something quite crude – take one room very slowly, read every word of every sign and study every architectural detail, then rush through the next room trying to grab a single image of it. Gradually, build up a range of subtle variations, accelerating and slowing according to the pace of your feelings.

## Perspective

Take a deep breath and blow along the horizons of your site.

## Pattern

Find a pattern in your site: a grid or zigzag in the paving slabs, a serpentine fence, a patchwork of cloisters or a figure of eight through the ornamental flower beds. Walk the pattern surreptitiously, discreetly, repeatedly.

This may bring you unusually close to people, you may overhear snatches of private conversation, or be forced to ask people to let you through; engage with them, eventually they may notice your pattern... don't hide what you are doing, but don't broadcast it either.

If you find a place with particularly strong shapes, recruit some friends to walk them with you. Start at different points and weave the patterns together.

This patterned walking can create a slight wooziness (as a maze makes us 'mazy' or giddy, changing our state of consciousness). Treasure this feeling, for such intangibles are counter-tourism's treasures; it doesn't have much in the way of artefacts in cold glass cases.

### Picnic Hampered

*Every picnic gets a little ambushed by its 'things': fly-attractive food, leaky flasks, over-excited fizzy drinks, collapsing chairs, inquisitive bullocks. So, in the 'Picnic Hampered' sections, there is a selection of such things to take with you on your ambushes. A counter-tourist can enjoy the difficulty of these things: they have just the right abrasiveness to push heritage around ;)*

*Take chalk with you. Leave coded messages outside ticket offices, mark a route, or carry it as a portable labyrinth.*

*In the early days of freemasonry, before the freemasonic lodges had their own buildings, the brother masons would hire rooms in inns where they would chalk the outline of the Temple of Jerusalem on the floorboards, before wiping it away at the end of their rituals. With chalk you carry in your pocket the outline of every iconic building in the world.*

## Bits...

Go with a friend. Take dark glasses. Take it in turns; one to shut their eyes, while the other leads them around the site, whispering lies about what they see.

Cup your hands around your eyes to cut down the light array and intensify the colours.

Lie down surreptitiously in a palace.

Collect as much dust as possible without being seen.

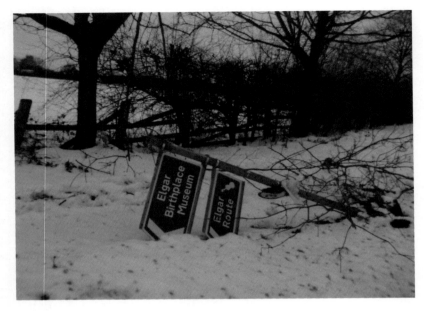

## Arty facts

Tourism Studies academics talk about 'tourism objects' which can range from a tiny souvenir to a superliner carrying thousands of passengers and crew. Visit something tiny, like a souvenir, as if it were a huge complex. Observe a huge complex as if it were a trinket.

## Wasted

Visit places of 'almost heritage', where significant things almost happened.

In 1921, a convalescing T. S. Eliot wrote a large chunk of his epic modernist poem *The Waste Land* in a shelter on the front at the seaside resort of Margate. He had intended to spend the time in Torquay, but changed plans at the last moment.

Why not visit one of the late Victorian shelters on the front at Torquay and enjoy the experience of being on the exact spot where *The Waste Land* was nearly written?

Todd
Dr Robert Bentley

*Physiologist*
KING'S COLLEGE HOSPITAL

Todd (1809-60) founded King's
College Hospital in Portugal
north of the Strand, in 1839
Professor of Physiology at King's
London, and became the first
of the King's College London
School.
remembered to the understanding
and gave his name to
paralysis.
'hot toddy' is sometimes
attributed to him, because
bed alcohol for his patients.

Saunders
Dame Cicely, OM

*Physician*
ESTABLISHED MODERN HOSPICES

Cicely Saunders
graduated as a
St Thomas' Medical Se
and founded St Christo
Sydenham, in 1967. Beli
dying is as natural as bein
transformed the way
patients were looked
a worldwide hosp
The Cicely S
of Palliative
the world
isbrute
and ed

Hodg
Dr Thomas

*Pathologis*
DESCRIBED HODGKIN'S DISEASE

Hodgkin (1798-1866) was
Curator of the Museum at
Guy's Hospital Medical School and
in 1832 he identified aspects of the
disease of the lymphatic system which
is named after him.
He advocated the system of student
involvement in bedside learning
which is still used today, and
in 1836 became a founding
member of the Senate
of the University
of London.

## Who are you?

No matter how 'counter' you're being, you're still some kind of tourist. For a long time the prevailing attitude was that 'tourists' were *bad things*. Passive dupes of a giant industry trampling over cultures they didn't understand. "*We* are travellers, *they* are tourists."

But there is another opinion – that tourists are people who pick and choose what and how they experience, who mix and match things and their feelings about them, making up their own leisure and heritage as they go along. That for all the packaging (and the extreme and green alternatives), tourists are pilgrims, up for transforming themselves.

Modern tourists – who in Europe first emerged in the educational travel of the sixteenth century (which in turn would become the 'Grand Tour'), later made romantic journeys into the wild, and finally went 'mass' with the coming of the railways – have often been described as 'pilgrims'; the beach or monument their shrine; self-transcendence (bodies tanned, minds broadened) their Grail. The questing counter-tourist is the same but different; a pilgrim without a destination, a hunter without a moose...

So, release your inner tourist; that haunted bit of you that never wants to work again, that believes your destinations hold magical things. Counter-tourism isn't high-minded tourism or even anti-tourism; it burrows inside the heritage industry, using the same resources as any tourist, but more sharply and intensely, and when it reaches the end of the pilgrimage... it keeps going.

## Crude

Analyse your heritage site as if it were a psyche: the id wild and obscene in the dungeon, ego trying to act normal in the kitchens, super-ego niggling and harrying in the guest rooms. Move between the different parts of the site, luring one into the other – see if you can coax the super-ego down to the cellars and get a real psychosis going.

## Aladdin

Team up with groups of recent arrivals to your town and go exploring for the local echoes, importations, expressions and appropriations of their own heritages.

## Public

Ring your local publicly-funded museum and ask if they have an arrangement for lending artefacts from their reserve collection to taxpayers for an evening. If not, invite your friends over to view their absence in your home.

## Smoothie

Initiate your own touchstone. Along a route you regularly walk, find a piece of brass or brick at a spot where one atmosphere changes to another – then rub your touchstone every time you pass it. See if you start a trend.

## The lost chord

On Orford Ness, the site of the former Atomic Weapons Research Establishment, the metal stairs on the outside of the derelict Ballistics Building resonates in the key of C major.

Listen out for other accidental Aeolian Harps; they are there to remind you of the role of chance, chaos and the weather in all of this.

Wherever you make your counter-tourism –
in your head, chatting in the pub, at official
heritage sites – take people with you. Be
convivial. Arrange to meet new people to try
out tactics.

The ideas in this *Handbook* come from trying
things out with people.

Because my home is in England, that's
where most of the forays happened; but this
*Handbook* should be mostly usable anywhere
– and where it isn't, it might be used as a tool
for turning that place into an 'anywhere'.
Every country has its own heritages, heritage
industry and possibilities for counter-
tourism. Share your finds at
www.countertourism.net

I look forward to meeting you skulking in
palaces and craning behind monuments.

With every encounter, you won't just be
changing tourism...

## Tells

I passed the window of a Tourist Information Centre in a Dorset town displaying a cut-out paper model of local celebrities, past and present, attending an imaginary street party for a real royal wedding.

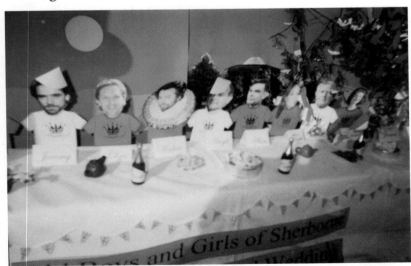

It was hard not to notice that the bishops, explorers and scientists of the sixteenth to the twentieth centuries had been replaced by the actors, Kids' TV personalities and D-list celebrity-aristocrats of the twenty-first; that something historical, but absent from the guidebooks, was being marked here.

Look out for such displays – those incongruous signs and presentations at heritage sites that betray a sudden burst of enthusiasm for revealing.

This often takes place when conservative heritage organisations bring in top-down changes of policy, sending out instructions to their officers to be "accessible", "imaginative" or "fun"; pressurised local staff go too far, guarded details come gushing out, and the unconscious of the place stirs like a beast in the deep, rippling across Visitor Centre, signs and information boards.

Keep an eye out for bizarre colour coding.

## The courage of your convictions

Ask yourself, at the end of your visit: "which of the fantasies that I entertained during the course of my visit, would, if acted out, have resulted in the longest prison sentence?"

## Shred

As late as the nineteenth century, superstitious country people would scratch stone from the statues of saints on the West Front of the cathedral at Exeter and sprinkle the grains on their wounds.

What heritage object would you grind up and sprinkle on your wounds?

## Genealogy

Go looking for the homes of your ancestors – aware that where your searches take you may be far more interesting for what they are now, and who lives in them today.

Tracing an ancestral line of butchers and slaughtermen, I ended up in the cellar of a goldsmith.

## More bits

Take a ghost with you. Or one memory. Or an itch never scratched. A doubt unresolved.

Leave a lock of hair. Leave a lot of hair. Or a note.

Where it's safe to do so, and your impact is no greater than rainfall, climb on the ruins.

Hold wrists, measuring each other's pulses.

Exchange kisses with a statue. (In the opening to Luis Buñuel's movie *The Phantom of Liberty* a character steals a kiss from a statue and receives a stony slap from another. Ensure feelings are mutual.)

## Ask

What political and historical narratives are depicted in the décor of Chinese takeaways? Enquire within.

## Monopoly

Use the pattern and atmospheres of heritage sites as human game boards. Play Cluedo at Bletchley Park, Scrabble at the Literary Club on St Petersburg's Nevsky Prospect, three-dimensional chess at Charles Jencks's Garden of Cosmic Speculation at Dumfries...

In 2011, at the end of a counter-touristic mis-guided walk around the Aldwych in London, I led the walkers in procession through the fountains in the courtyard of Somerset House risking the random explosions of the water jets. Immediately, onlookers began to copy us, photographing each other as they did.

Devise games for symbolic spaces.

## Home

Domesticate iconic heritage sites. Do a bit of dusting in Buckingham Palace as you pass through.

These spaces are, very often, domestic spaces, but the residents are either ignored (poor) or in hiding (powerful).

Who lives in your heritage?

## Focus

Examine the materials with which a statue or monument is made. Look for folds, dykes and fossils in its stone. These are not neutral media, they have their own histories. The monument is just the latest staging post of their geological journeys.

## Viewing point

Lobby train companies to provide at least one carriage on all trains that is kept in darkness at night, so passengers can study the shapes and shadows of the landscape by the lights of the moon and earthly communities.

### *Picnic Hampered*

*Your body is the best instrument you have for peeling open a heritage site – use it as a scalpel, as a microphone, as photographic paper, as a sponge.*

*Stand still and feel the flows of air; let atmospheres rather than signs lead you; register the different intensities of your embarrassment.*

*This is both frivolous and revelatory. Enjoy the gentle thrills; those feelings are just as much markers of historical things done and ambiences remaining as a court document or an early photograph.*

## Castles in the air

Fall asleep on monuments. Write a guidebook to the dreams you have there.

## Health and Safety

Many apparently unnecessary health and safety signs can be usefully re-interpreted. For example, the sign "Historic sites can be dangerous, please take care" erected outside English Heritage sites should be taken seriously. If the past eats your brain, your vacant smile will be taken for customer satisfaction.

## Toys

Carry small plastic animals. A lion – pad around. A spider – catch the place in a network of ideas. Unicorn – skewer it.

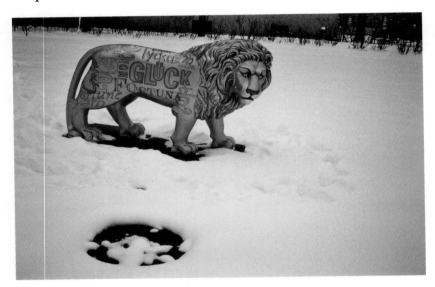

## Toe

Use your feet to explore – use boots to nudge, toes to hold, heels to test the texture. Kick, push aside, rub... use your limbs as guidebooks.

By deploying your feet you keep your head back from the object of your interest, so you see it all the time in its context.

Walk a site barefoot.

## Relatively speaking

Curator Christine Johnstone has described how her visitors most strongly respond to those historic artefacts to which they feel

they have a family connection, crying out to each other "your granny had one of those!"

Try this at palaces – point at golden thrones, silver maces, long and dangerous-looking spears, full-size billiards tables and stuffed alligators, shouting loudly to each other "your granny had one of those!"

## Occult

The centre of the English city of Plymouth is a windy, post-war shopping development, designed by Sir Patrick Abercrombie. It is not generally loved. What Abercrombie neglected to tell anyone was that his architecture is a philosophical work influenced by Feng Shui. (I'm not making this up!) His first

ground plan for Plymouth looks like a Kabbalah tree of life. (But no-one knows.)

Walk the shapes in your landscape to reclaim the ideas hidden from you there.

Search for occult, hidden, private and personal patterns in public space.

When statues, coats of arms and carved stone symbols fell out of fashion,

architects began to hide their signs and sigils in modernist grids, postmodernist pillars or pseudomodernist wavy roofs. All around us are ideas, shaping what looks old and comfy, or contemporary and functional: patrician designers exercising their esoteric power.

Walk such shapes as if they were Nazca Lines; those vast markings in the Peruvian desert, some of spiders and sharks, others abstract and geometrical, made for a ritual walking that transferred the power of the things represented, and the patterns that underlie everything, to the walker.

Take back the power.

## All that

Look not at the stained glass propaganda, but at the abstract colours it throws on the pews.

## Dimensions

Use small, 2D cut-outs of the profiles of iconic buildings from around the world and hold them up against the views of your local landscape – create a fluid terrain. And have a laugh. (Thank you to Anoushka Athique for this idea.)

Rather than seeing just the distance and difference between your town hall and the Pyramids at Giza, or between your school corridor and the Brooklyn Bridge, you may find more similarities than you expect. Try with some really big cut-outs, say two metres high. Then actual size.

**You may not need a reason for doing these things, but if you do... it might be because the heritage business is like the moon: it has a dark side.**

**Because behind those simple-sounding stories in the Visitor Guide and the locked gates marked PRIVATE, there lies a multitude of wonders, absurdities and outrages that, when counter-tourism opens the doors, provide a subversive and life-twiddling experience rather than a deferential procession through the unrevealing homes of the rich and famous.**

**It's not because the heritage industry is dull or bad or conservative or inaccurate (ahem!), but it just doesn't seem to realise how odd, surreal, dreamy, horrific, elusive, ruined and apocalyptic it all is.**

Upset the heritage industry's mission to stop us getting over excited while they sell us comfort in old places, cocoa for history, and Victoria Sponge Cake. Exploratory pleasure is your means to ends that nobody knows yet (AND a large piece of that Victoria Sponge Cake, please).

## San Gimignano

When in doubt, push the envelope... though, perhaps the Torture Museum *was* a stupid place to take a small child.

## On reflection

Use the viewing mirrors provided inside tall heritage buildings to slice off part of the space and turn it on its side.

## Yawn

Get a cheap A-Z guide to dream symbolism. Try the 'Body, Mind and Spirit' section of your local library. Or consult one of the many websites. Use these dictionaries of symbolism to interpret heritage sites as if they were dreams:

Castle = a reward

Museum = a quest through many rooms

Tour Guide = protection against snakes, good fishing advice

Guided Tour = your only chance to kiss Elvis in Graceland or meet the Butterfly Man

Glass case = a place to say hello to The Beatles

Suit of armour = lighten up!

Devoid of science, these dream dictionaries fall back on a strange kind of common sense. Use your dream dictionary as a guidebook to your site.

## Assembly

Create your own heritage landscape on a shelf or windowsill or on a kitchen table. Collect together your own and friends' souvenirs purchased or found at various sites. Arrange them into a miniature hybrid-heritage destination. (The concentration of souvenirs creates a map of unexpected life journeys and connections.)

Invite people over to pay a visit. Lay on tea and scones and don't skimp on the clotted cream.

## Punktum

Over the years academics have given tourists a hard time for choosing their holiday destinations from brochures and then going to these destinations and taking photographs that are almost identical to those in the brochures.

You could take photos *of* your brochures (that's a big saving on travel and accommodation).

Or take a photo of a brochure image, transfer it onto a t-shirt; then, at your destination pose in front of the subject of the photo for the benefit of other photographers. Can you get your upper body to disappear into the site, so your head balances on its top?

Although most academics now see tourism as a rather more freely chosen and self-made activity, the attitude that tourists are passive dupes of the tourism industry is still dominant among artists and the media.

In photographer Martin Parr's collection 'Small World' one of his photographs shows tourists posing by the Leaning Tower of Pisa, pretending to hold it up. By taking the image from the 'wrong' angle the tourists appear to hold up fresh air.

When you are next in Paris pose holding up the Bourse, or in any dictatorship pose trying to hold up the Presidential Palace, in Moscow hold up the Lubyanka, likewise the National Diet in Tokyo or the Zhongnanhai in Beijing; seek out any place of wealth or power and pose heroically attempting to save it from collapse.

## Careful now...

Walk across a heritage site as if it were a thin skin of ice or glass.

*"Under the West Norwich streets there are old chalk workings... They open up occasionally and a bus disappears..."* (D.J. Taylor, *Real Life*, 1992)

### Picnic Hampered

*Take along a small plastic sachet of materials and little objects. Keep it in your pocket until you feel it's the right moment. Choose an object and place it against your skin, securing it under a belt or in a sock or glove: a small ice cube, a square inch of velvet, a burr, a piece of chocolate, a pebble, a grandparent's medal, a Teamsters' pin...*

## Heritage object

The wreck of the SS *Richard Montgomery*, and its cargo of 1,400 tons of TNT, sits on the riverbed at the mouth of the Thames Estuary. There is an exclusion zone around it, and it is constantly monitored visually and by radar. Sunk in 1944, it remains at risk of erupting as a result of collision or attack or the spontaneous combustion of its interacting materials; the precedents for attempting to neutralise such a wreck are unpromising.

If it does explode it is expected to send a five metre high wave up the Thames.

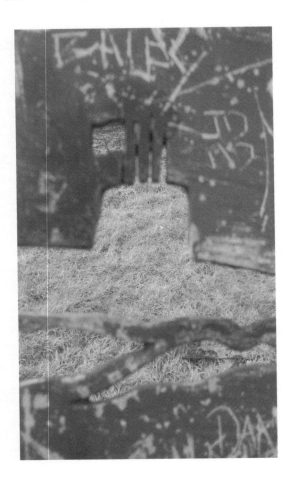

Take this as your default model for heritage artefacts.

Visit heritage sites as if you were members of a bomb disposal squad. Move very, very carefully. Assess the site's potential dangers. Treat all offered information with extreme caution. Then carry out a controlled explanation.

Avoid chit-chat on counter-touristic forays; make each visit a special quest. Heritage renders the extraordinary ordinary so, to get 'special' back, try to focus entirely on the site. Make the place the thing you share your feelings and associations about. You can always chill out in the café afterwards and talk about the tennis; disrupt your 'usual', then disrupt your disruption and slip back to the everyday.

## Shifting heritage

Rather than visiting ruins and palaces, follow the routes of quirky walkers who were driven to make strange journeys by necessity or eccentricity.

Many people in Europe today are re-tracing the escape routes of Second World War prisoners.

But has anyone yet re-walked the trek of Harry Bensley who in the first decade of the twentieth century attempted to hike around the world wearing the helmet from a suit of armour and pushing a pram? He began at Trafalgar Square...

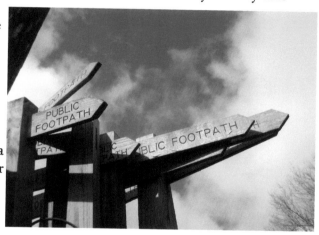

Others whose footsteps you could follow are Charles Hurst planting acorns (*The Book of the English Oak*), W. G. Sebald being depressed (*The Rings of Saturn* – but did he really go?), Pink Floyd's Syd Barrett walking back to his Mum, poet John Clare walking from asylum to freedom, the eponymous hero of Rachel Joyce's *The Unlikely Pilgrimage of Harold Fry*, film director Werner Herzog trying to heal a friend (*Of Walking In Ice*), the Peace Pilgrim (her name speaks for itself), John Davies 'Walking The M62', Roy Bayfield 'Walking Home To 50', Simon Whitehead walking a drovers' road from Wales to London with a stuffed goose, performance artists Marina Abramovic and Ulay

walking the Great Wall of China from opposite ends (they'd intended it to be a celebration of their relationship, but, by the time the Chinese bureaucracy agreed, it was their 'divorce'), the benevolent stalking of Sophie Calle's *Suite Venitienne*, Simone Kenyon and Tamara Ashley on the Pennine Way... search them out and re-walk their walks. Use them as launch pads to your own adventures.

I began my own retro walks in 1990 among the crowds on the Nevsky Prospect in St Petersburg, re-walking scenes from Andrei Bely's *Petersburg*:

> *Contemplating the flowing silhouettes, Apollon Apollonovitch likened them to shining dots. One of these dots broke loose from its orbit and hurtled at him with dizzying speed, taking the form of an immense crimson sphere...*

Next time you take a holiday to a heritage destination, rather than fly back on the final day, visit the site on arrival and carry the first sight you have of it home with you, setting off immediately to walk back. Or take something enormous – be like Alyson Hallett and travel with huge stones.

Photo: Sean Malyon

> **If you hear music, walk to its beat. Bach in the bus station, Gregorian chant in the cathedral cafeteria, Tinie Tempah on the promenade. When there is silence, walk to the beat of your heart.**

## Holmes sweet Holmes

Visit a 'historic town' as if you were undercover detectives posing as tourists. A tourist is a perfect cover for detectives (see David Mamet's movie *The Spanish Prisoner*).

Explore heritage sites as if they were crime scenes. As if a terrible offence has been committed there and everyone is a suspect.

Prepare the case for the prosecution.

## Entering, but not breaking

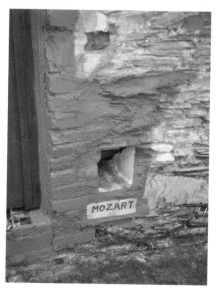

I remember how, as teenagers, my friends and I would slip into the park of an Abbey in the English Midlands (it's now a luxury hotel) – not to damage anything, but to savour its strangeness when deserted, to watch the still and silent playground in the moonlight.

Visit tourism sites 'out of hours'.

## Pieritage

From the painted figures and their settings on a pier or funfair or from the images on one-arm bandits, fruit machines and penny falls, write a heritage:

> *"Our earliest settlers dug for gold and since then 'sparkle' has been our currency. Our women dress in clothes like flags, while our men carry long silver lances. A messiah came in a suit of white; he simplified all life to a dance; his name was 'Disco'. No-one knows why, but this led to a bombing war."*
> (The South Pier, Lowestoft.)

## Sex tourism

Seek out erotic landscapes: the tunnel at Fountains Abbey in Yorkshire, say, the Hell Fire Caves near West Wycombe, Mamucium ('the breast shaped hill') today called Manchester, Naasa Hablood (Somalia), The Breasts of Aphrodite (Mykonos, Greece), Twin Hills, Alaska (pop. 69), or one of the many Temples of Venus that crowd English country estates.

Play 'Stupid Cupid' in your head and pair off the visitors wandering around.

I once met a Tourism Studies academic who told me of a dilemma in the marketing office of a Dutch stately home. The house had been the setting for a well known porn movie – the tourism officers were uncertain whether or how to

acknowledge this heritage, but were tempted by the potential for publicity.

What porn movies might have been filmed on your site?

Book into a hotel with a view of the Eiffel Tower (or similar erection) and compare the vista with your own organs, goosebumps and hardened nipples.

Create sets of famous and historic places in your bedroom, erect tableaux of historic moments and enact scenarios where sex might have changed history or architecture for the better (the pilot of the 'Enola Gay', overcome by lust for his lover, turns the plane around and heads for home).

Visit your partner's body, as if it were a palace, a gift shop, a vista, a Visitor Centre.

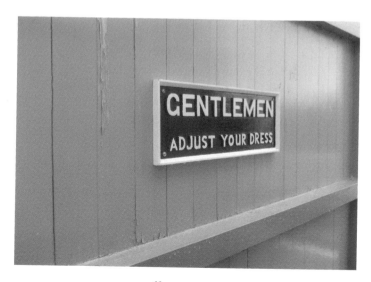

## Growing up

In a children's playground on a 1950s-built suburban housing estate I found the remnants of a 'cut and laid' hedge: a tiny patch of the once open fields now concreted over, a narrow strip of raised earth from which the once interwoven branches of a country craft had now grown out.

Look for the past poking through.

### Stem Cells

Anybody can use the tactics of counter-tourism. It isn't an academic activity. But that doesn't mean there can't be any ideas. So every now and again, into the petri dish we're dropping these little cultures...

Geoillogical: have you ever heard people describe a place's prehistory as "Paris in the age of the dinosaurs", "Jurassic Kerman" or "New York 400 million years ago"?

Deceptive nonsense, really. Not just because the cities and their names have only been around for a few

hundred years, but because "in the age of the dinosaurs", in the "Jurassic" period or "400 million years ago" the rocks on which Paris, Kerman (Iran) and New York are built were neither together nor where they are today.

Those rocks have travelled thousands of miles on a multitude of different paths. They have risen up into mountains, crumbled away into deserts, been swept by floods and then risen again,  metamorphosing under hideous heats and pressures, faulting, folding and eroding.

Those places called Paris, Kerman (نامرك) and New York are simply the latest staging posts on these rocks' long nomadic journeys.

The deep time of geology is an opportunity to understand just how slippery 'identity' is, and how the naming of places is always hopeless. The moment after the word 'Shanghai' was first spoken, Shanghai was already a different place. Trying to hang on to the thing fixed by a name can end up with a horrible violence being done to the thing itself.

## *Arrête, c'est ici l'empire de la Mort*

The landscape is made up mostly of corpses.

Those limestone hills are mostly the billions and billions of bodies of tiny sea creatures from 400 million years ago. The sands of the beaches are mostly eroded from those corpse mountains. We mostly power the cities with fossil fuels. Unwanted pheasants, surplus to the requirements of corporate shoots, are ploughed back into the soil. We live in a giant vivacious grave. When a pig is eaten by maggots it soon flies.

When you get home bury one of your souvenirs.

## Part objects

In the Italian Gardens of the English holiday town of Weston-super-Mare, the face of the statue of Vanity is pitted and deformed by wind erosion and the effects of acid rain. Nearby, a headless stone hawk has caught in its claw a stone sparrow it will never be able to devour or release.

Collect photographs of statues with missing parts (it doesn't have to be their genitalia!)

Imagine a park of lost limbs and organs. The human body's equivalent of unwanted statues of Karl Marx and Hungarian workers.

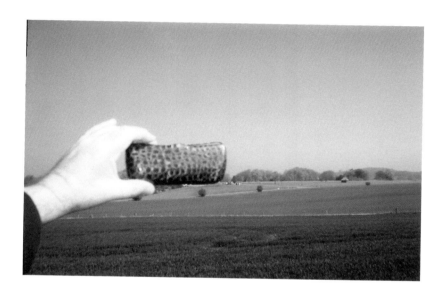

## Blot on the landscape

Find out the source of the wealth that paid for the construction of a heritage site. Take along an example of whatever commodity it is (a packet of Indian tea, a piece of cotton, a lump of coal, a sachet of blood). Photograph the site from a distance, holding the commodity in front of it, so that the one obscures the other. A piece of linoleum to obliterate the Ashton Memorial in Lancaster. A cinema ticket in front of the replica Taj Mahal east of Dhaka, Bangladesh.

If you get a chance, visit the English town of Bungay in Suffolk. A black dog is everywhere. It's on the town's badge and is its brand image.

The origins of the 'Black Dog of Bungay' lie in a thunderstorm that overwhelmed Suffolk on Sunday, August 4th 1577. Lightning struck the church of St. Mary's; two of the townsfolk who had gathered there for shelter were killed. An account published within a month described how a black dog "or the divel in such a likenesse" rushed through the church "in midst of fire... passing onwards to the quire (choir) he many people slew". Bungay has been associated with the Black Dog ever since.

So far, so historical, apparently: a strange but coherent set of events, with an unbroken tradition. In fact, very 'historical'. For this 'coherence' is made up of gaps and leaps of invention: the parish records of 1577 say that the two fatalities took place in the bell tower and not in the "quire", and mention no dog. The author of the canine-enhanced account, a Calvinist propagandist and translator of 'Of English Dogges', appears not to have ever visited the town.

And as for the "associated with... ever since" – well, the Black Dog story was excavated from obscurity by a Town Reeve, Dr Crane, as part of a mid-1930s' campaign to revive the town. Crane combined housing and welfare projects with a selective resurrection of town traditions; in the face of industrial collapse (Bungay's river had silted up and was formally closed to trade in 1933) he transformed the town's image from one of post-industrial decline to that of modern visitor destination.

In order to overcome local opposition to the erection of the town's first electric lamp post, Crane seized on the Black Dog as the perfect symbolic ornament. Lightning = electricity. The local paper devoted a two page spread to his antiquarian research and a design competition among the town's children democratised the sleight of hand, turning a

modern appliance into a pseudo-antique curio, an ambiguous 'heritage' everyone could own. By the mid-1940s the local football team coach had adopted the name 'Black Dog' and the pattern was set. Today, almost every local sports, arts or social organisation in Bungay has the black dog in its name or on its badge.

So, there *was* a past. Things happened. But history was made back to front from the way we are told it is; as much about a 1930s' lamp post as a Tudor devil – what look like causes are effects. While the past itself, as ever, moves away from us, like the stars.

Heritage alchemists like the Dr Cranes of this world make history *for* our pleasure. Dr Crane conjured the Black Dog with economics and electricity from a free-floating fragment of theological propaganda in order to entertain, distract and 'add value' to his town.

Counter-tourism, on the other hand, makes history *from* our pleasure.

But I still like Crane's 'Black Dog'! Not because it reaches back to a deep, pre-modern 'English' folk past (in this case it almost certainly doesn't), but because I love its shape-shifting, its modernity, its electricity, its duplicity, its popularity – its all round doggy-dodgyness! It is both a spasm of invention *and* a remnant of the never-existing past.

Like effective flirting and successful attacks, both sporting and military, the best counter-tourism is that which takes uncertainty and implausibility to the brink of the laughable without falling over, sustaining as many ludicrous possibilities for as long as possible.

Such ecstatic heritage is not an anchor in what came before, but, like a devilish dog of energy racing through a sacred chancel, a quest for what might be to come.

## Pilgrimage

Walking to catch a train, I passed an old cast-iron sign – 'To Worcester Cross, 1 mile' – and this changed the walk for me; I was treading now in the footsteps of pilgrims.

How can you assign a destination to a path so that you change the journeys of the people who use it?

'The grave of Pickles, the dog who found the World Cup – 3 miles'

'400 yards to mediaeval red-light district'

'1,356 miles to the holiday home of the former President'

## Tedia

If visits to museums, castles, guildhalls and redundant pumping stations bore you, then push your feeling further – get woozy, fall for a full-scale hallucination, go for coma.

## Identity

Find any unprepossessing path or track, corridor or underpass, preferably far inland, and rename it 'Smugglers' Lane'.

## Bigger than yours

Find a heritage site about which unsupported assertions are made, be they unfeasibly grand:

> *"D------- - the only nation in the world where you had people risking their own lives in order to save the Jewish population."*

unlikely:

> *"M------- is perhaps the only British town with a historical family connection to the development of the Japanese shipping trade."*

or unnecessarily modest:

> *"S-------- may justly lay claim to the title of being one of the prettiest small towns in Dorset."*

and make your own unsubstantiated assertions about it.

## Beating the boundaries

At night, walk from the centre of your city to an edge you do not know. As you go, feel out for former city walls and boundaries.

In Paris, with the help of Frédéric, I crossed a former city

boundary where wine sellers on the city side had pushed pipes through the wall to the other side, so the country drinkers could draw their wine without paying city taxes.

When you reach the edge of today's city, stare out into the darkness of the fields, across the waves, the abyss, the ice, the sands, the corn.

## Nostalgia

Emma and I took a trip on a steam railway and saw how in the past all the workers cared for the comfort and security of their wards, how there was no interest in profit but only the safe transport of body and soul, how cigarettes were good for you, even how small towns all looked like New York back then and how everywhere was more than one thing.

Use a 'nostalgic' heritage site as a means to re-imagining the past as the best it could possibly have been.

By taking nostalgia 'at its word' resurrect unachieved ideals.

## Attraction

Visit a Tourist Information Centre or gift shop as if *it* were the tourist destination.

## In the dark

When you've read this paragraph, close this book and put it down, and for one minute shut your eyes and touch a surface: it may be clothing, skin or something or someone nearby. Feel its abrasions, sedimentations, scars, the marks of its past. Then come back here.

Now close your eyes again for another minute, touch the same surface, but this time feel for any associations, memories or stories that rise from your touch. Then come back here.

Next time you're in a heritage site, take with you and touch that same something or someone and feel out any connections between your associations and the site.

## Goggle-eyed

Deploy 'Khlestakovian inscrutability' when seeking information from heritage officials, ushers, invigilators or guards.

How does it work?

The trick is to give as little away as possible about what you want to know or where you want to look; leave huge pauses in your conversation, as if you are expecting the official to say more or point something out or lead the way. This creates a vacuum that many people will rush to fill, often with materials that they would not otherwise reveal.

By deploying this tactic (named after an eccentric tramp who is imagined by a small town's population to be a powerful state official in Gogol's play *The Government Inspector*) I have been

informed enthusiastically about the positioning of snipers around Horse Guards Parade in London and ushered by an initially obstructive concierge into a fragrant bouquet factory in a basement in Naples.

## Vernacular

Use heritage 'quainteries' for a day: 'townsfolk', 'days of yore', 'rascals', 'handicrafts', 'yesteryear'...

## Starring

Bathe heritage spaces with associations from your own mental film library. Take inspiration from the atmospheres, shapes and juxtapositions of your sites to conjure movie sequences or sensations.

In St Petersburg, I joined with Inga, Paul, Olga and Andy to storm the Winter Palace (although that only really happened in the Eisenstein movie; so, a double inauthenticity).

In crowds be Spartacus, up towers and tall buildings be King Kong or Officer John McClane, on rainy freeways be Janet Leigh, in wastelands be Stalker, in bunkers be Traudi Junge and in sites of industrial heritage be Ripley in mechanical prosthesis.

## Secret Satan

Very often a tourism organisation does not forbid or cover up uncomfortable or inconvenient truths, but, by corralling information around a few select stories, it renders what is unwanted sufficiently marginal to be mostly missed.

So dig a little in the footnotes of local history pamphlets, ask a few awkward questions at the Tourist Information Centre. That's how we discovered that the missing figure in that tableau of a Dorset town's celebrities was... Nazi broadcaster Lord Haw Haw.

## Stem Cells

By now you may have tried out some of the tactics in this *Handbook* or in *Counter- Tourism: A Pocketbook*. On the ground or in your head.

If so, then this is a good moment to forget the tactics for a while and watch other people in heritage sites. Some will already have their own handbooks – guides, brochures, audio tours. Some listen to commentaries and follow the guide's instructions. Others don't quite buy it, and look to the side, hang back, scratch and prod...

For them, there's no history there to find – not any 'history' in the sense that the heritage industry uses the word – a coherent, chronological, meaningful, articulated past – *that* went the moment it was made, and we've been concocting stories about it ever since. History is now, it *is* the looking to the side, the hanging back, the scratching and the prodding.

Early mediaeval sailors were charting the west coast of Ireland, when they accidentally mapped the same island twice. When they came back years later to visit the two islands, they could find only one, so they mapped the second as being farther off. And the same the next time they failed to find it. And the same again next time. Further and further out to sea the second island travelled. And for every visit, stories of this receding island became more exotic – it was perfectly round, it was the home of a lost clan, its name was Hy-Brazil. It drifted so far away that Arctic explorers saw it floating above the ice.

So perhaps we should re-name that floating mirage that passes for history as Hy-Story, and concentrate more on how we make it by our fanciful mapping, a phantasm above the wastes of remnants of 'The Past'.

## Auto

Keep a diary of your explorations of heritage sites. But as someone else; it could be as a person 'from history', or some visitor you once glimpsed in a heritage site or a shadowy part of yourself.

## Darkside

With Cathy and Simon, I found a 1970s' telephone exchange with large corner windows designed for conversion to machine gun positions. In chalk we drew the lines of fire on the pavement.

Competent architects, past and present, don't just design the bricks and mortar, but the gaps, empty spaces, affordances and shadows. For many of them, their designs come from, represent and feed organising ideas, agendas, powers and beliefs.

During the night, walk around the shadows of iconic buildings, and draw the outline of their night time shadows in chalk. So in the daylight they linger.

By marking you begin to map the history of intentions.

## Borders

Always check the backs of monuments. Scour the margins of paintings for outrages and giveaways.

## Stem Cells

What do I mean by 'heritage'? For the purposes of this *Handbook* I mean anywhere that the heritage industry *says* is 'heritage'.

But what if they designated 'Now' as heritage?

Even worse, what if the future was commandeered by the industry?

Welcome to my nightmare.

To inoculate yourself against this possibility, listen to the futuristic music of the past on your visits to heritage sites: composers like Wendy Carlos, Gary Numan, Delia Derbyshire,

Isao Tomita and Desmond Leslie – almost anything played on a Moog synthesiser, the airport music of unrealised utopias.

Use your mental library of images from futuristic films and novels to perform the same trick.

Visit the remnants of former futurisms, such as the modernist Resort of San Zhi in Taiwan, or the 'grounded space-port' of Forton Service Station (M6, near Lancaster).

The new becomes an instant ruin; some literally, others subtly. The cheaper and more mediocre pseudomodernist buildings of recent urban regenerations are instantaneously abject; some are so bad they're good.

In 1990 I visited a park for Soviet technological achievement in Moscow. Between some odds and ends, salvaged from the space race, were achingly empty exhibition halls – yet people still came, using the gaps for their own pleasures. Such voids are precious and relatively rare. Treasure them. They are spaces for optimism, temporary free fields of unrealised energy.

## Your time slip is showing

I went to my Turkish barber for a haircut and as I admired his photographs of the 'caves' at Göreme he beat me on the ears with flaming cotton swabs to burn away extraneous hairs. Despite the pain, I couldn't help but make the connection between the hollowed rocks and my ears. Many businesses and

institutions use such self-defining, iconic and historic images: at the dentist's I stare at a waterfall in Yosemite on the ceiling ('quick swill?') – what part of your body or what passing thought do these iconic sites attach themselves to?

## The right place

Plan an extensive tour of various iconic world heritage sites. Pack your bags. Don't go.

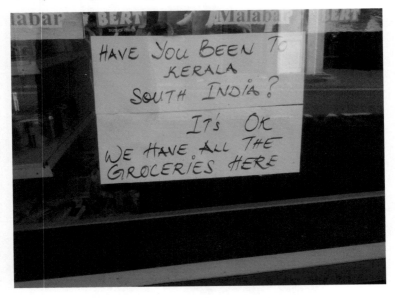

How long can you leave your bags before you can no longer resist the temptation to unpack them? Resist harder!

Do the bags take on some of the qualities of the unvisited sites?

## Triffids

"The spreading of foreign, unwanted intruders... has taken on a threatening form... the violent attack of foreign species has become a terrible scourge over the land to be fought with all available means."

In the UK, the major heritage and wildlife trusts organise 'Rhodie-bashing' days for the clearing of 'non-native' plant species from their lands. (There is only one possible source for this phrase – 'Paki-bashing', racist slang for racially motivated assaults on British Asians.)

On Lundy Island the extermination of black and brown rats (the *Untermenschen*) is intended to privilege the birds (*Übermenschen* and, coincidentally, mostly white). Brown rats were previously known in Britain as Hanover Rats; a slur on the country's imported German monarchy. In Yellowstone Park the extermination of wolves, in the interests of large and 'virtuous' mammals like bison, deer and elk (following the violent expulsion of Crow and Shoshone Indians, their oppressors carrying the sublime in one hand and a Winchester in the other) led to the elks exterminating the vegetation, and 70 years later the rangers had to bring the wolves back.

The 'English oak' was introduced to Britain approximately 6,000 years ago, possibly as part of the waste brought and dropped by hunter-gatherers, or as a result of planting by early farmers. To those naturalists who take the formation of the

English Channel as the cut off point for indigenousness, the oak is not a native British tree.

The stated logic behind the assaults in the UK on Japanese Knotweed, Himalayan Balsam and other 'alien invaders' is that they support fewer species than 'native' plants (true, though often they support more biomass), that they do not have the same cultural associations as the 'native' plants (associations for whom exactly?), that they disturb traditional habitat (traditional in the sense of the industrial revolution but not traditional in the sense of the seventeenth century or mediaeval landscapes), that they oust established species (not really, that has mostly been done by the same people who want to attack these ones too), and xenophobia (nuff said).

Carry replica Japanese Knotweed to drape around noticeboards carrying 'speciesist' notices.

### *Picnic Hampered*

*Carry a stick, for pointing out improbable details and warding off conventional assumptions.*

## Home sweet home

Take a tour around your own house or flat. Then plan a tour around just one room. Set up a tent on the landing. Have a picnic in the bathroom. Crawl about the lounge. Put your eye to the carpet; admire its plains, valleys, mountain ranges and landfill sites, pyramids, temples and autobahns. Excavate in the drawers.

Once you've tried all this a few times, give your friends a pre-prandial tour next time you have them round to dinner.

During a foray to the stately home of Somerleyton Hall, Lorraine described to me how her Peruvian-born mother gave tours of her home to new visitors, keeping objects strategically placed so they could serve as props for her narration. Her mother had turned Lorraine's childhood tartan kilt into a cushion and this now illustrated the moment in the tour when her mother told of first meeting Lorraine's father, a Scot, lost in the maze at Hampton Court. On her mother's tour no photos or artefacts are used, only symbolic representations.

Turn the ornaments of your home into a narrative of your own heritage.

## Web

Find patterns as you go, mentally loading one on top of another:

The mediaeval spiral patterns in the church.

A gate, part fallen, looked cubist.

A huge funfair, closed and silent, its serpentine rides coiled like the scroll shapes in the church.

The crosses in the Crossley carpet at the stately home – were we trampling the cross?

A yew hedge maze.

Spark photography once used to monitor the flight patterns and corresponding airflow of bullets and shrapnel fragments...

## A Borges map

Feeling an oppressive obligation to visit heritage sites? Make a list of every heritage site in the world. This unending task will save you from ever getting round to ticking any of them off.

## 'Know thyself'

I was asked to make a 'mis-guided tour' (more about them, later) at the nineteenth-century Royal William Naval Victualling Yard in Plymouth. I had only one tenuous connection with the Royal Navy – a half-uncle I had never met – and, as far I knew, zero connection with the Yard.

However, it turned out that my half-uncle, Uncle Clarrie, of whom my Gran regarded me as the reincarnation, had in 1939 collected his Mediterranean uniform from the Royal William Yard just before his ship, the *Royal Oak*, was redirected to the cold waters of Scapa Flow in the north of Scotland, where it was torpedoed and Clarrie was killed.

Pretty much every time I get asked to make these tours, I find an

old self coming the other way.

At Taunton I found a junkyard full of tyres laid out in oddly pleasing patterns, triggering a dim emotional memory of watching the opening junkyard scene in the very first episode of the UK sci-fi drama *Doctor Who*; the whiff of pikelets and hot butter for Saturday tea, the day after Kennedy was assassinated, 1963. I began to experience the town in monochrome for a while.

The more you know about your own pasts and those of your family, friends and colleagues, the more you can riff off them. Talk to your folks about the whats and wherefores of your collective pasts. Nose around in drawers, photograph albums and document boxes.

While there is a danger of self-indulgence in this, the weaving of subjectivities into the narratives of heritage can paradoxically help make your visits less vulnerable to unthinking identification with the dominant script of the heritage industry.

The easier and more often you can interweave autobiographical associations with what you find at heritage sites, the more you can put the subjective back into sites that are organised specifically to exclude it.

## Azimuth

Find a bust or statue. Where do you need to stand, lie, bend, jump, lean to meet its gaze? What is the significance of where it places you?

(Don't fall off the battlements.)

## Entropy

In the Visitor Centre café order a black coffee and a portion of cream. Gently drip a little of the cream into the coffee. Let it form a pattern on the surface. Now stir it in four clockwise circles, mixing cream and coffee together. Then, exactly

reproducing your action but in reverse, stir it backwards in four anticlockwise circles. The cream and the coffee will separate out, as you would expect, just as historians, curators and site-managers can separate the events of the past from the perceptions and presentations of the present.

## Blue sky thinking

Check the backgrounds and underlays of displays – the bath mat under the bison, the hopeful, Elysian skies above the model battlefield.

Check pub signs for incongruous and anachronistic landscapes.

## Stem Cells

Have you ever noticed a certain sameness about heritage sites? As if, whatever the place or past, there's a common 'heritage script', often overlapping with a 'tourism script'; different subplots of a common drama that we're all supposed to play our parts in. And that these destinations and objects come with accompanying values, ways of behaving, and even 'appropriate' feelings.

These things, feelings, dramas and values are not enforced through any one agency, of course, but are parts of a web of stories that dominates movies, guidebooks, TV programmes, novels, advertising, images, signage and the tales that people tell each other about their own pasts.

Tourists don't necessarily swallow this whole. In fact, they get much of their enjoyment by jumbling up the different elements of the scripts, selecting choice bits and improvising

new activities around them. They get lost along set routes, touch things they're told not to, and photograph and film objects from non-prescribed viewpoints.

It's actually this free activity that works most potently to keep the regimented story webs alive, refreshing them in new combinations, interweaving them with personal choices and associations, threading personal identity around potent fantasies about peace and quiet, the eternal nation, identity under siege, the superiority of the past over the present, unity, the sufficiency of lukewarm fun, the continuity of tradition and the transience and insignificance of change. Indeed, the spontaneous feelings that these stories can trigger and the sense of their being freely chosen by their consumers are now just as, if not more, important than the stories themselves.

They are a glamour through which the stories take on a new life. But that does not mean these stories will last inevitably, universally and forever. On the contrary, tourism is one of those spaces where place and meaning are in a constant state of being made and re-made from ruins, and where ideas, appearing in their simplest and oldest forms, are open not only to change, but to destruction and re-assembling. The tourism site is one of the few places where anachronism is radical; because it can force ideas back to their simplest forms, in which state, robbed of complexity, they struggle to contain the contradictions between their parts.

The quest of counter-tourism is its picking through the ruins, its pilgrimage around the bits and mess, its poking into gaps and splits and poking again but harder, its transformations of these sites under the guise of conservation and preservation, its heroic journey through the gift shops, its rearrangement of the remnants until they are recognisable as something else – this is ecstatic heritage. And whether you're happy making subtly different visits or devising more complex and invasive interventions, it's all part of the same quest (which is to all be on different ones).

## Doctor Mintern

A shady, certainly fabulous and possibly fictional organisation called the Equi-Phallic Alliance (motto: Unity Is Length) has, since the 1990s, sporadically published a newsletter – *The*

*Listening Voice* – in which they claim that the landscape of England is an invention, and that the surface appearance of rural peacefulness and order is held up on stilts.

One night the Alliance sent an expeditionary force to attack a hill in Wessex; penetrating the outer skin with mattocks, they tumbled into the "hollow heart of England", otherwise known as the Underchalk.

Recently public authorities, when organising the repair of iconic buildings, have taken to covering these buildings with full-scale representations of the structure underneath. Perhaps some of these were then left in place once our eyes had become accustomed to the representations, while the actual buildings were removed.

In Stephen King's novel *The Tommy Knockers*, aliens use a device to 'fill in' the appearance of a damaged part of a Town Hall, so all will appear 'as normal'.

If you ever find your way into the Underchalk or behind the full-scale curtain, perhaps through some invisible damage inflicted by crashing aliens or road-building, then take command of the props, braces, scaffolding and appearance-machines. They are no more difficult to master than a child's set of play-tattoos.

## In breathless anticipation

Write a diary of a holiday you haven't been on yet. Use things you have around the house to mock up your snaps of iconic sites and majestic views. Make traditional costumes for places that don't exist. Cook up local delicacies from regions you've never heard of. Make a scrapbook of intentions.

*"it's a poor sort of memory that only works backwards"* (Lewis Carroll)

## Pass the port

For your next visit to the beach, design your own sandcastle flags: abstract expressionist flags, prayer flags, personal flags, peace flags, pirate flags, anarchist flags... persuade other sandcastle makers to build routes between their domain and

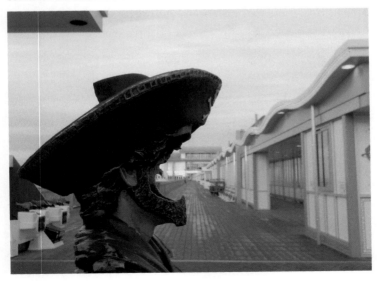

yours. Write treaties. Organise diplomatic visits along the seashore. Perhaps nations, states, diplomacy, borders, and pomp and circumstance are things we could just do in the summer holidays?

## Comments

When filling in the visitors' book on leaving your hotel, motel, guesthouse or B&B, describe the dreams you have had during your stay.

### Picnic Hampered

*Collect your own miniature statuary for assembling on restaurant tables, hotel room dressing tables or bar tops, as your own personal Hősök Tere (Heroes Square) – Mozart, Buddha, Chewbacca, and so on...*

## Questions to ask a tour guide:

*Have you ever used Wikipedia and would you admit to it if you had?*

*What should we do during the times when you are not talking?*

*Could you do a tour without pointing?*

*Is it possible to be right about history just by guessing?*

*Who leads the guided tours you go on in your dreams?*

## 'After you, Cecil...'

Experiment with new uses for the 'Claude Glass' – this is a framed mirror with its own handle, devised in the nineteenth century for the 'better appreciation' of the picturesque qualities of the landscape. The user frames and observes the landscape in the mirror's reflection (while standing with their back to the vista).

Make your own version of a 'Claude Glass' and use it in tourism sites to locate yourself and your site in the wider landscape. Observe your own reactions in the glass, frame your performance of being a tourist, face 'the landscape' and use the glass to look over your shoulder to see what sees you.

## Stem Cells

When counter-tourists hijack heritage sites to make new meanings, that's not so different to everyone else – using the existing 'scripts' to make their own personal variations. But

there is one big difference. Mainstream heritage tourism provides a script for tourists, like actors, to animate by the force of their individuality; but the 'character' is *already there* in the 'script'. Whereas counter-tourists are more like 'live artists' or drunks on a Friday night; they're making it all up at the time, 'in the moment' – rather than dependent on

rehearsal – ripping up the old script, ignoring the old 'characters' and improvising something else. If things have been going well for you, you may already be in a script of your own making.

## Ironic-Platonic

Use big concepts and grand patterns as mental maps for negotiating your next visitor attraction.

Before you go, choose a philosophy, a dynamic pattern or a manifesto to study and carry with you.

For example: take Jane Bennett's vital materialism for a visit to a nineteenth-century anatomy theatre, or the patterns of Penrose tiling on a trip to Byland Abbey, *The Communist Manifesto* might

still come in useful on a visit to Wall Street, Kierkegaard's *Concept of Dread* for a trip to the Bagnoli industrial wastelands near Naples, Tolkien's 'On Fairy-Stories' for a trip to Disneyland, or Jean Moréas's *The Symbolist Manifesto* for a stroll along the Nevsky Prospect.

## OO

Miniatures and models of all kinds are susceptible to accidental juxtapositions, inappropriate contexts or sudden poetic changes of scale.

Sheer weight of numbers can change a cute tableau into a

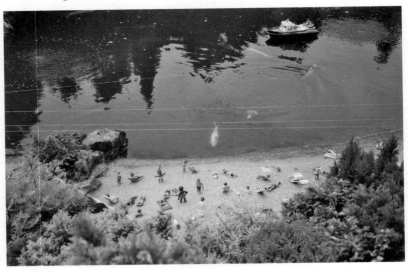

Wagnerian monstrosity.

Check out the crowds of figures and clusters of model landscapes in window displays. They often hint at full-scale heterotopias (utopias without walls or shores).

Look out for model villages and giant ice cream cones – there's something about those perversions of scale that encourage a 'blurting out' of what generally lies ignored or unspeakable.

At the 'Great OO Model Railway' in Exmouth, initial ambition and subsequent neglect have fostered an extraordinary

combination of the apocalyptic and the everyday. Across the huge model railway many of the tiny human and animal models have fallen over and lie flat, like corpses, or seem to trip, keel, writhe or falter. The model fields are like mass graves. One hill has been ripped open by an unimaginable geological force, a gargantuan coffee mug sits balanced across freight wagons, and every quotidian village scene has its corpses and wildly leaning fainters... lack of repair has allowed the insides to appear: "like Chapman Brothers pieces but with more integrity".

Model villages are apocalypses on a domestic scale; their speeded up miniaturisation suggests the imminent dereliction of iconic architecture and civilised behaviour. They are erotic, abject, political, ecological.... they are the *ids* of their sites.

At the enormous(!) 'Miniatur Wunderland' in Hamburg, the flora are ornamental, the fauna are human-obsessed predators

or people in animal skins. The population of 300,000 figurines possess only 10,000 cars between them. The Wunderland stitches one continent to another with all the voids edited out (except for the huge doors in the sky).

At 'Babbacombe Model Village' (not far from the 'Great OO Model Railway') the layouts are well-maintained, yet still feverish with surreal juxtapositions and ironies. Tiny sunbathers in a beachside scene are terrorised by monster goldfish just offshore. Miniscule hunt saboteurs clash with police while in a neighbouring field a gargantuan Green Man strides by. (Outraged at the lack of Druids at the miniature Stonehenge, the Grand Bard of Exeter smuggled in some tiny ones.) And the

site's maintenance workshop is open to the public; the Statue of Liberty and the Sydney Opera House lie in a pile of discarded landmarks.

Next time some planner or building firm turns up with a model for your new town centre... check on the happiness of the pedestrian figurines.

## Solipsism

Have conversations with any representations of ghosts, pirates, slaves, revolutionary leaders and Neanderthals that you come across on your heritage visits – see if you can persuade them into dialogues with each other: ghosts with scientists, pirates with Marxists, slaves with ladies-in-waiting, Neanderthals with metaphysical poets...

### Stem Cells

Walk. Simple as that: as much as possible, walk. Not just in heritage sites, but to them and away from them and around them.

Walking allows you to use a body, with billions of sensitive instruments of perception and billions of motor controls, at a pace that frees you to compute its findings.

Use your feet, your toes, your nose... sit on things, lean on them, hug them, move them with your boot. Smell them, lick them.

The destination-less wander is the key tactic, the tactic in all the tactics of counter-tourism. It's sometimes called the 'drift' or 'dérive'.

This kind of walking can help you to measure

things, estimate distances, feel the incline,
and all the while sense the passage of time.
Pace in anticipation. Meander, at a one-mile-
an-hour stroll. Collect viewpoints. Tread the
borders, toe the lines.

## The enemy is rent!

Wherever possible, pay no entrance charges.

As an ordinary visitor I was excluded, on the grounds of health
and safety, from visiting the 'pagodas' of the former Atomic

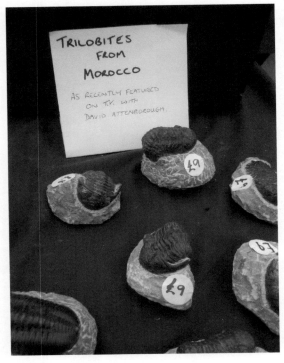

Weapons Research
Establishment
on Orford Ness,
while a specialist
party were allowed
in; perhaps ruins
never fall on those
paying extra?

It's rare to see
these distinctions,
but there are
many heritage
sites where donors
are discretely
wined and dined
and taken for
privileged tours
once the public
have gone home.

*"My immediate reaction to 'counter-tourism' gave me a vision of
you sitting behind a desk in the middle of nowhere selling tickets!!!"*
(Christine Duff)

### Picnic Hampered

*At harbours, on vintage vessels and along 'smugglers' paths', wear a piratical black eye patch.*

*Pirates wore eye patches not to cover wounds, but so that if hand-to-hand fighting shifted from the upper deck to below decks, they could switch the patch and rely on an unaffected eye already adapted to the darkness.*

*The patch will help remind you to keep switching the way you look at your site.*

*Rose-tinted spectacles help too.*

## Cover

Dress in historical costume for your next heritage site visit. But don't act a character. Just use the costume as a way of being there.

Pay a visit in Victorian or Edwardian dress to 'The Village' at the Metro Centre, Gateshead.

Or ditch the costume, and adopt the character of a historical figure who has disguised themselves as you.

## A different angle

When visiting a historic building ignore everything except the corners – now what do you understand?

## Weather

On a hot sunny day wander around the birthplace site of Robert Falcon Scott. Now part of a residential area

of Plymouth, the bombed and long-demolished Outlands was where the young Scott of the Antarctic would lead his siblings on expeditions across the glass roof of the mansion's porch, prefiguring his journeys across ice.

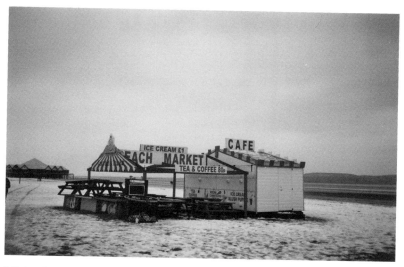

Visit the Palace of the Sun King in the rain.

As snow begins to fall, visit sites of monumental architecture:

*Within one mile of*
*here there is*
*No lovelier place to*
*walk than this,*
*On days when these*
*kind flakes decide*
*That what it boasts*
*of, they shall hide.*

(Alan Brownjohn,
'Snow In
Bromley')

## Vacuum

Next time you visit a site of heritage, do the best you can to resist taking any significance from it at all – then you'll feel the meaning-machines wriggling and stitching, trying to get back into your vacuum, and you may get a sense of how you make meaning without meaning to.

Free yourself from any guilty obligation to learn and understanding will fill its place... and even if that's not true, you'll probably have a better time.

## Potential

Visit those spaces where plans were unrealised. Savour their cheated potency:

The site of Francis Godwin's "wildly classical" Grand National Cemetery at Kidbrooke near Shooters Hill or that of Thomas Wilson's 'Pyramid of Death' near Primrose Hill (both London). Sir Edwin Lutyens' model for a new, commercial English village

at Cockington, Devon. Moscow's Palace of the Soviets or Frank Lloyd Wright's 'The Illinois' in Chicago. To grasp the morbid life of these plans watch again the scene in the movie *Downfall* where Adolf Hitler and Albert Speer discuss their lost future over an immense model of a New Berlin:

**Adolf Hitler:** *How many thousands of hours have we spent on these magnificent models? ...Only you and I realise that a Third Reich isn't possible if it only consists of department stores and factories, skyscrapers and hotels. This Third Reich will be a treasure house of culture that will survive the millennia. We see before us the ancient cities, the acropolis, we see mediaeval cities with their cathedrals and we know that people need something like this, a centre. ... That was my vision...*

In, rightly, rejecting such totalitarian monumentalism, why has the post war era left a heritage that *is* mostly "department stores and factories, skyscrapers and hotels"?

There are morbid monuments to economic crisis, national and personal; unfinished constructions that prematurely expose

their skeletons and innards: the pillars of the Bangkok Elevated Railway and Road System, the cadaverous Szkieletor (Skeletor) skyscraper in Krakow, the M8 'Bridge to Nowhere' in Glasgow, the remains of the unfinished Olimpijka motorway in Poland, Jim Bishop's vertiginous 'Bishop Castle' at Wet Mountains, Southern Colorado.

Treasure these rare survivals of 'not to be' – their traces remaining only because of the cost of demolition. The bottom line that inspired most of them, then disrupted them, now preserves them.

### Stem Cells

Why are there more movies than historians in this heritage handbook?

Because heritage is a hallucinatory entertainment.

On visits to heritage sites take *at least* a double-vision approach: on the one hand assemble a mass of information that upsets the existing narrative. And, on the other hand, intuit the site's emotions, visions, atmospheres and associations.

The movies help with both.

## Actors

*"An off-duty costumed Henry VIII at Hampton Court Palace said he found it a bit difficult after work, because he had people bowing and scraping to him all day long, and in the street his mind kept expecting people to do the same!"*
(Penelope Dearsley)

If you encounter so called 'interpretation' (this is the professional term for those who dress up and perform 'historical persons') then throw sci-fi into reverse, borrow a backing up 'arrow of time' from Martin Amis, and imagine all those peasants, farm workers, miners, princesses, lords and maids winding back to their impersonators.

What car does Henry the Eighth drive? Does Catherine the Great prefer dub step to hip hop? How did Joan of Arc vote in the latest *Big Brother* eviction?

## Inquizitive

Questions to ask at your site's Tourist Information Centre, Visitor Centre or Reception:

> *Has this place ever had a different name?*

> *Has any event ever traumatised the community of this place?*

> *What is the most common complaint here?*

*Are there any hidden gems in this site that visitors don't normally get to see or hear about?*

*Is there anywhere here that you are afraid to go?*

*Is there anything you would advise us not to do?*

*Where would we find the nearest monster?*

*Is there anywhere or anything here that you have dreamt about?*

Make up your own questions; questions that you cannot imagine answers to.

## Tours within tours

Plan a visit to a traditional heritage site.

Make a preliminary excursion alone and take the official guided tour.

Then go a second time, but now inviting along one or two

friends. Take the official guided tour once more, but in the time between your two visits plan a tour-within-a-tour for your friends.

During the official tour, provide your friends with a parallel 'commentary' that is olfactory (dabbing their wrists with perfume), sensorial (slipping them tit bits to suck) and, maybe very occasionally, whispered – exposing your friends to critical or complementary tastes, whiffs and comments to accompany the official narrative.

*Make sure that you do not disrupt the tour*, be undetectable and invisible – a real 'ghost tour' – containing your tour within the official one.

### Picnic Hampered

*Mainstream heritage tourism is deeply implicated in the morbid marketing of violent death as a form of entertainment.*

*In the eighteenth century the stars of the English stage would use a 'tragic carpet', a piece of cloth onto which they would fall during their death scenes, to protect their expensive stage costumes.*

*So take a 'tragic carpet' with you (any small piece of cloth will do) and use it to acknowledge deaths as events with a significance independent of entertainment value.*

*Lay out your carpet, lie down and think about the dead.*

87

## The Declaration of Interdependence

The linguistics theorist J. L. Austin described "infelicitous speech acts" as pronouncements such as "saying 'I name this ship ---- ----' when you have no business to".

Which begs the question – who *does* have a business to?

Try performing some "infelicitous speech acts" in a heritage site: hold a re-opening ceremony, snip tape and declare it open, or re-name it, or reassign it as a memorial to something... Honestly, if you've got this far in the *Handbook* you can invent your own infelicities.

Philosopher Jacques Derrida trumped Austin by declaring that "all speech is infelicitous". (Including, presumably, Derrida's declaration that it is.)

### Tip

Keep a notebook. Sketch the outline of any paint spills that you come across – one to a page.

After a year lay them out on a large sheet of paper or across a floor: an almanac of accidental ghosts, a yearbook of pavement squids.

Now you have a map of tiny, accidental heritage sites.

> **You do realise that you can make up your own tactics? And if you think they're any good, share them with other counter-tourists – at www.countertourism.net.**
>
> **Recipe for making new tactics: get a rough idea, try it out, before you let it form into anything, test it again, and just keep testing it until it becomes something you hadn't imagined. That pretty much makes you unpoliceable (even by yourself).**

## Illusions

From a train I mistook a caravan park for a cemetery. Make a collection of things you glimpse out of the corner of your eye.

> **Hypersensitised yet? You'll know when you are because you'll be able to feel, without any tactics, the pulls on the slithering layers of the places you visit, you'll sense their motion... you'll suddenly grasp the politics of 'peace and quiet'.**

## The humu touch

In 1966 a London artist, Tom Phillips, inspired by the cut-up technique of the novelist William Burroughs, set off......
We'll come back to this... just for a minute you need to put the *Handbook* down, hold on, read the next bit first – go back to a heritage site you've already visited at least once, only this time leave the *Handbook* at home, and just *feel* the site (you can do this

in your head, or get your coat and go) – touch it, yes, but also let yourself feel it, nothing more. If you need a trigger, perform a little private gesture at what for you are the most affecting parts of the site (hand on heart, tongue on your lips, ear to the plaster), breathe in hard, breathe out slowly, next breath let the site in, let it *feel you, touch you...* OK, back to Tom Phillips, setting off with threepence in his hand, prepared to purchase any second hand book he could find for sale for that amount. The book he bought was a copy of W. H. Mallock's novel *A Human Document*. Over the next few years Phillips proceeded to select a few words from each page – words that formed their own sort-of-poem. He then obliterated the rest of the page with a variety of illustrations: abstract, psychedelic, erotic, kitsch. First published in 1973, Phillips' 'treated book' – now called *A Humument* – was an instant success and remains in print (though much-changed) today.

W. H. Mallock, author of Phillips' raw material, was born in 1849 at Cockington Court in Devon, a small stately home with its own estate, which includes a church that was once administered by the Premonstratensian canons proper of the nearly Torre Abbey. In the remains of this Abbey, under a ruined arch, is a plaque on which has been engraved an eighteenth-century poem. Wind and rain have eroded many of the words, just as Phillips eroded Mallock, and a new poem has emerged:

> Though hallowed
> The friendly Abbey
> Here meek religions
> How great, how fall'n
> Of sacrilege, behold
> Nor blush
> Here stood
> The dome
> The shattered
> The yawning
> Sad striking remnants
> To pity now might move

Lo, sunk to rest, the wearied
While o'er his urn the gloom
Here silent pause, here draw
Here musing learn to live here

Collect eroded texts that render up new poems or William Burroughs-style cut-up prose.

If you write poems, leave them outside for the winter.

## Stubborn

Photograph all the stains in a heritage site.

## Hoity Toity and Argy Bargy

When it comes to the absurd content of nursery rhymes, old dances, obscure sayings and symbolic mummery, innocent explanations and sinister revelations are equally to be distrusted.

The apparently inoffensive song and dance 'The Hokey-Cokey' ("you put your left leg in, your left leg out, in, out, in,

What if the Hokey Cokey really IS what it's all about?

out, shake it all about, you do the Hokey-Cokey and you turn around, that's what it's all about"), often performed at parties, is in fact "all about" the satirising of the gestures of Catholic priests officiating at Mass, and "Hokey-Cokey" (like "hocus pocus") is a corruption of a phrase from the Catholic liturgy, the consecration of the host: *"hoc est enim corpus meum"* – "this is my body".

Or it may be a night club game inspired by the use of cocaine by, and its effects on, Canadian miners.

Or, it was taken from the cry of an ice cream seller: "Hokey pokey penny a lump, have a lick make you jump!" "Hokey pokey" being a corruption of the Italian: *"ecco un poco"* or "here's a little one!"

Settling on which (if any) of these is true, is probably far less interesting than considering why priestly ritual, drug-fuelled mining and ice cream coexist in such close relations. (Which should be done while watching comedian Bill Bailey's rendition of the 'Hokey-Cokey' in the style of German electro-band Kraftwerk.)

## Back in 5 minutes

If you visit museums and galleries when they are closed, the glimpse of their collections through chinks, gaps, windows and blinds may provide illuminating slices, reflections, isolations, distortions and reassemblages of their artefacts.

## Whatever

An air control tower sits at the heart of Martlesham Heath housing estate in Suffolk. A remnant of the airfield on which the estate was built.

> **Wherever you are at this moment, on the battlements, in your kitchen or in a childrens' playground with a rampant hedge, look for history poking through.**

"They all float!" (from *IT* by Stephen King; and if that isn't a book about heritage...)

## Band on the urn

Visit a place through the music of its local band. Canterbury through the fantasies of Caravan or Muskegon (MI) in the manner of Iggy Pop.

## All around

There is a theory of mediaeval history called the Phantom Time Hypothesis which proposes that 300 years of history were invented and inserted into the orthodox account of the mediaeval period.

This unlikely hypothesis is a result of 'researchers' grossly exaggerating a discrepancy between the Julian and Gregorian calendars.

However, such busted hypotheses can be useful and entertaining. They suggest what more successful and acceptable historical theories (made by people who imagine everyone is as sensible and honest as they are) might not – that large chunks of our history are made up. That 'periods' and 'eras' (with adjectives or proper nouns in front of them) are self-aggrandising efforts to

appropriate history after the event or the remnants of successful ideological manoeuvres at the time.

History is made up in the same way that I am making up these words and that you are making up your mind about them.

Apply absurd theories to the places you visit; first of all, for your own entertainment; and every now and then they will provide an accidental insight that more rational study could never have brought you to.

## Bio

History hangs around in bodies – Chernobyl, Hiroshima, DDT – everyone carries some small part of everything with them. We walk on tons of dust from Mars. While the Cosmic Microwave Background (vibrations of the Big Bang forever rippling outwards through the expanding universe) passes through us all of the time.

Many of us it now seems, but not all, carry the DNA of Neanderthals. So maybe all those artists' impressions of dumb looking Neanderthals are 'wrong'; they should have depicted thoughtful, intelligent people... It will be instructive to see how those images change now that scientists have drawn a line to include the Neanderthals in 'our' history; already, cave paintings at the El Castillo site are being attributed to Neanderthals. And who will be the first to claim Neanderthal DNA as a mark of racial superiority?

How far astray are we led by historical reconstructions and re-enactments? What is the impact of certain colour schemes and the attractions of conflict and drama? Will Richard Nixon always now be Anthony Hopkins? Margaret Thatcher always Meryl Streep? How much longer will the pyramids be built by slave labourers (when the archaeological excavation of their accommodation suggests that they were skilled workers)?

A sculpture by the French artist Emmanuel Frémiet – 'Gorilla carrying off a woman' (1887) – virtually single-handedly created an image for Europeans of a rapacious and violent monster before almost anyone in the West (including the artist) had seen a gorilla in the wild. And gave us King Kong.

Emmanuel Frémiet, French 1824–1910, Gorilla carrying off a woman 1887, bronze, 44.7 x 30.6 x 33.1 cm, National Gallery of Victoria, Melbourne, Gift of the artist, 1907

Approximately 300 million sharks are slaughtered by humans every year, many stripped of their fins and thrown back into the water to drown. How many people are killed by sharks in any year? Twenty? But then everyone's seen Steven Spielberg's famous documentary: *Jaws*.

Explore your own body for signs of familial, ancestral, environmental and cosmic history.

How would you like that heritage portrayed?

How might it be?

### 'Payant'

Compare the car parks of different heritage attractions.

### Remote viewing

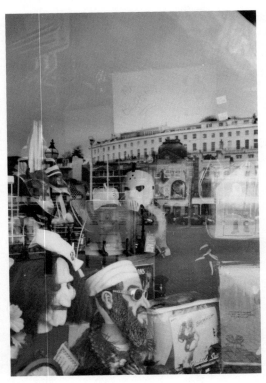

On Mytho Geography's Facebook page, 'Mytho' (in fact, me) got into a dialogue with FB friend Luther Blisset Mountbatten (who has since changed his name!) who had tagged us in a photo of an abandoned cinema at Marasca in Italy. It had pleasing 1950s' lettering. The cinema had replaced a previous building, a *teatro* that had been commandeered by the fascists as a cultural centre. It had been destroyed by US bombing at the end of World War Two and then been rebuilt. The present cinema had closed in September 1994 and 'Mytho' speculated on whether the

theory of psychodemiurgics (which proposes that theatres are haunted because when the actors move on they leave the characters behind, hungry for existence) might also apply to film projection. Together with other FB friends 'Mytho' wondered what might have been the final film to be shown in the cinema, what phantom images last bathed its screen and whether their ghosts were still there. Luther suggested he visit the cinema once more (though abandoned, it is structurally solid) to look for posters that might reveal what that final movie was...

This is a kind of remote tourism. Social networking makes for all sorts of possibilities for surrogate exploration. It allows the remote tourist to make speculations on the basis of what a friend 'on the ground' can tell or show them – uncertain of how distant or authentic such reports might be – for distance, fiction and proximity are all useful in generating different kinds of impressions and associations.

## Ranters

See how much of a site you can be offended by if you really try.

## "an error occurred, please try again later"

In Rosslyn Chapel, near Edinburgh, a great stone beam is
decorated with a depiction of the seven deadly sins on one side
and the seven virtues on the other. Or it should be, but the
mason apparently made an error and for one of the blocks he
carved the figures on the wrong sides. He reversed the places of
Greed and Charity. Unable to begin again without replacing the
entire structure, the mason seems to have settled for installing
his error. So Unrestrained Appetite took its place on the side of
virtue, and Selfless Love among the sins.

Imagine the effect on a heritage site if you could reverse a part of
it. Can you?

## They can only say "no"...

I stayed at 'The George' in Stamford, a famous inn, a coaching
station during the eighteenth and nineteenth centuries; it still
has separate waiting rooms in its foyer for passengers to York or
London. In the notes on the inn's history left in all the rooms, I
saw that the inn's cellars had been built on the twelfth-century
foundations of a hospital of the Knights of St John of Jerusalem;
the direct antecedents of today's medical charity, the St John's
Ambulance Brigade.

In the morning, before I had breakfast, I asked at reception if it
was possible to visit the cellars and to my surprise a porter was
immediately summoned, chairs and carpets in the cocktail bar
were pulled aside, a trapdoor was opened and we climbed down
into the remnants of an early mediaeval chapel dedicated to St
Mary Magdalene.

## If you don't ask...

At Castle Drogo, Devon – the last grand-scale country house to be built in England – the finely worked granite pillars of the family's house unexpectedly carry on down into the boiler room.

There's a whole world of 'underground' down there – annexes of the Underchalk – crawlspaces and tunnels, ice houses, ballrooms, underground hospitals, cellars and artificial caves.

If you don't ask...

## Close-up

In the small English town of Bovey Tracey, I found the names of Second World War US soldiers and their home states, Tennessee and New York, carved in tiny letters into the red bricks of what is now a restaurant. Those locals I pointed them out to had not noticed them before.

Attend to the texture, for a while stay as obsessively close to the detail as you can.

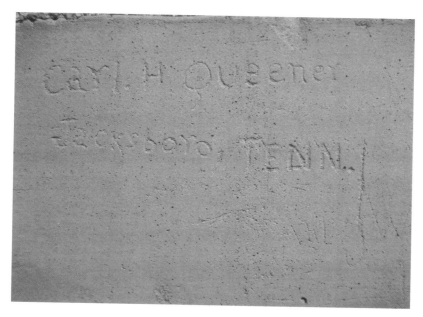

## Strategic Reserve

During the Second World War plans were drawn up in the UK to assemble large numbers of steam engines as a reserve supply of locomotives for use in the event of a German invasion of Britain. The locomotives were never actually gathered together but, because no record of the order being countermanded existed, a belief grew among steam enthusiasts that somewhere, hidden, was an El Dorado of old engines.

Eventually, someone did the documentary legwork and found the records for the dismantling of all the steam engines that were on the Strategic Reserve list.

Today, many steam locomotives have been conserved and are used to pull weekend excursions on main lines. How absurd to think that they might return to play some role in a future catastrophe! And yet, in Cairo's Tahrir Square in 2011, tour guides from the pyramids, mounted anachronistically on camels, attacked pro-democracy protesters.

*"Be prepared to fight the past."* (Lord Baden-Powell... no, not really.)

## Centre circle

Today, few visitors can walk among the stones of Stonehenge without first having to invent a religion. Save yourself the trouble and find one of those stone circles installed by landscape designers on traffic roundabouts or in leisure parks, set up your own Visitor Centre there, being careful (as at Carnac and Stonehenge) to ward off any visitors from the objects themselves.

If none are available, make your own. Erect one on the grass verge of a motorway service station. Or behind a supermarket. Where resources are limited, use pebbles.

## Stem Cells

Counter-tourism does not seek the Holy Grail of an accurate history. Though it does seize gleefully upon the upsetting of myths by empirical means. Even better though is Slavoj Žižek's 'third pill' – neither the blue pill of illusion nor the red pill of reality without illusions, but rather a pill that reveals *the reality that is in illusion itself.*

## Indifference

I went to the Tourist Information Office where, as usual, there was little information. (In one Tourist Information Centre, which shall remain nameless, I was once told that "there is nothing to see here"!) Instead I was offered a map of a nearby country manor which I approached by following a river rather than roads.

(Un)fortunately I was holding the map upside down and I became lost on dark paths, stumbling briefly along a disused railway track and then entering an expanse of dead woodland. Emerging from these suffering trees I found a signed road junction and made my way, now under a fierce sun, back to the town I'd begun at, along what turned from a quiet lane into a narrow but dangerously busy 'A' road.

Unnerved and unrewarded, my shirt covered in salt stains, I came upon the commemoration stone for the opening of the town's by-pass in 1987 set in the mouth of a dark cave of bushes.

I sat down next to this despondent site on a seat donated in memory of a local man "by organisations with which he was associated" (these organisations were either so secret or so numerous that they could not be named). I read a chapter from McKenzie Wark's *The Beach Beneath The Street*. White vans and saloon cars roared by, something substantial moved in the undergrowth. I had rarely experienced such contentment in the countryside.

Exploration by ordeal cannot be fabricated; getting lost on purpose is charmless. But by cultivating a certain indifference to maps, you can increase your chances of a landscape suddenly turning on you and opening up the abject heritage that it hides less openly in plain sites.

Hold the map upside down.

Heritage is in ruins – even when it's a modern heritage. Even when smoothly packaged, it will still be falling apart just under the surface. From the get-go. Behind the shiny information board and beneath the smoothly mown lawns, great chasms are opening up. Believe me – I've worked in these sites – I know how ruinous they are; I found the remnants of a Georgian obelisk forgotten in a gardener's shed, I could take you to the site of an old manorial-style farm that was accidentally demolished instead of the adjoining labourers' cottages, I was warned in one site not to mention the mass grave (less than 70 years old), and in another was requested to respect the sensitivities of its financial backers and avoid any reference to alcohol or slavery – which was interesting as it was the site of a former brewery on the quayside of an old English port! At Pendennis Castle in Cornwall, English Heritage asked the writer of a Second World War-themed ghost tour to remove all references (all perfectly responsible, I've read the script) to Nazis, Jews and Poland, for fear of offending visitors... visitors to a Second World War site! Need I go on...?

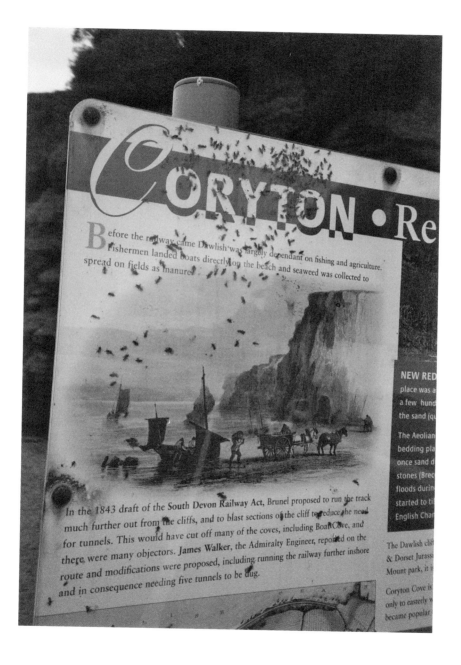

# CORYTON · Re

Before the railway came Dawlish was largely dependant on fishing and agriculture. Fishermen landed boats directly on the beach and seaweed was collected to spread on fields as manure.

In the 1843 draft of the South Devon Railway Act, Brunel proposed to run the track much further out from the cliffs, and to blast sections of the cliff to reduce the need for tunnels. This would have cut off many of the coves, including Boat Cove, and there were many objectors. James Walker, the Admiralty Engineer, reported on the route and modifications were proposed, including running the railway further inshore and in consequence needing five tunnels to be dug.

**NEW RED**
place was a
a few hund
the sand (q

The Aeolian
bedding pla
once sand d
stones (Brec
floods durin
started to til
English Chan

The Dawlish cliff
& Dorset Jurass
Mount park, it i

Coryton Cove is
only to easterly
became popular

## Mussel-bound

At www.countertourism.net, print out your counter-tourist badge – and use the secret greeting if you see a fellow counter-tourist (left hand over groin area, right hand over right eye, grimace, hold for one second, no further communication. Where the guards are armed, a wink will do ;-)

The badge logo is a mussel. The Royal-Dutch/ Shell Oil Company stole its scallop badge from early tourists – the pilgrims on the way to Santiago de Compostela – so we're stealing the original badge that Shell abandoned in 1904: the giant Ocean Quahog mussel (*Arctica islandica*).

## In pieces

In a Heritage Centre car park I found an eighteenth-century wax kiln, dug up in the local High Street and transferred to the Centre's new site on an Industrial Estate. Each of its bricks still carried the number it had been given when the kiln was dismantled.

The giant Soviet statue 'Worker and Kolkhoz Woman' by Vera Mukhina, made for the 1937 World's Fair in Paris, is stored in numbered pieces at Lot 16 of a Moscow industrial estate.

Perhaps we should start numbering *everything* so that future historians can re-assemble 'now' in the future's car parks? If this sounds absurd... well, yes it is, but less costly than the work of those demagogues intent on re-assembling the past as if they were painting by numbers.

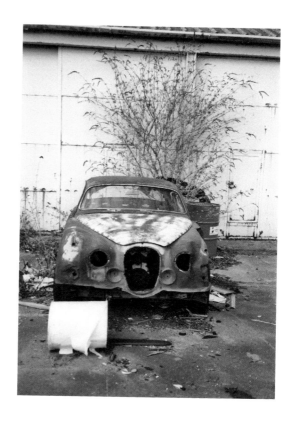

### Is there an agenda here?

O yes. No secret about that, the agenda is a set of ideas about place and space that celebrates the multiplicity of meanings in any site, heritage or not (and lots more) – it's called 'mythogeography' (check it out at www.mythogeography.com or in the book *Mythogeography* (Triarchy Press, 2010)), it's what gives counter-tourism its special emphasis on the *sites* of heritage; the *places* first, their stories second.

## Layer cake

Is there a code of conduct for the site you are visiting? Rewrite it.

*Code of Conduct for Mythogeographical Excavations In West Dorset*

1/ Apply the principles of stratigraphy to the layer cake in the café under the Information Centre.

2/ Excavate the emotional memories of your companions. Cruelly exhibit any finds in the glass cabinets of your conversation.

3/ Where visitors are using hammers hired from the Information Centre join them on the beach to recreate the 'bone into spaceship' scene from Stanley Kubrick's *2001: A Space Odyssey*.

4/ No heckling of acts in the Jurassic Theatre.

5/ er....

Implement the code for one site in another.

## Fall

At Dunwich I bought a souvenir; an unfolding strip of photos and prints showing the slow, century-long collapse of All Saints Church over the cliff and into the sea. Spilling the contents of its graveyard across the beach. This dread scene greatly increased the popularity of the town as a Victorian visitor attraction.

Use Photoshop to produce your own fantasy collapses of iconic sites over the edges of cliffs.

What would their undergrounds spill onto the beach?

Upload your images to the counter-tourism website at: www.countertourism.net

## Trailing off...

Many cities, towns and villages have a 'history trail' along which a restricted number of generic sites, artefacts or objects are identified as significant.

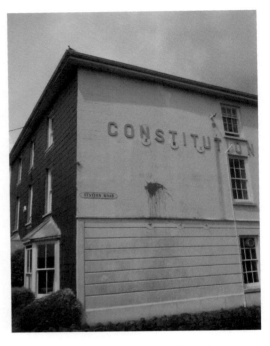

Before you make your visit to such a place, acquire a copy of the trail leaflet and then leave it at home. When you make your visit, collect new sites, artefacts and objects from which to make your own history trail.

My anti-trail visit with Diana first crossed the official trail at a mill that produces 'security paper' (cheques, banknotes, bonds) and then again at the monuments that nervously edge the main car park, but after that rather than a bridge, viaduct, aqueduct, churches, town hall and school, our trail included the site of a missing geocache box, two discarded cash registers and a bacon slicer, a designated 'Performance Area' shaped like an eye, a lexicon of accidental hieroglyphics (adhesive shapes left behind on walls by fallen signs), a black, private Royal Mail letter box, male and female toilet symbols transgendered by graffiti, and a lane called Costly Street. Hypnotised first by the blue light emitted from the brand-new self-service machine in the library and then by the red explosion of paint on the side of the Constitutional (Conservative) Club, Diana and I sought refuge in architectural structures of ox liver, bacon and mash at a riverside café and savoured the finds of our alternative trail.

## Wet brainer

Visit a maritime museum as if you were underwater.

## Zombie

In George Romero's *Dawn of the Dead*, the zombies turn a shopping mall into a historic site.

> **Francine**: *What are they doing? Why do they come here?*

> **Stephen**: *Some kind of instinct. Memory, of what they used to do. This was an important place in their lives.*

Next time you go to the mall or supermarket, visit it as if it were an enormous museum artefact from a post-apocalyptic civilisation.

## Walking in thought

I caught myself standing in the concourse of London's Liverpool Street Station, un-focusing my eyes in order to see the travellers as patterns formed by the exits and entrances, as flows encouraged and prevented by the overlapping designs.

In a popular heritage-tourism site, un-focus your eyes and, by observing the patterns of the visitors, read the minds of the site's designers.

## A salty dog

Kris and I caught the train, passing through the birthplace

of St Boniface, famous chopper down of sacred trees, and alighted to explore, under a scorching sun, a series of Devon villages whose names include either Nympton or Nymet: pre-Saxon words meaning sacred wood or grove. That was the full extent of our information and we had no map. Our aim was to find and mark the site of a new sacred space.

We walked shady metalled roads and bridle paths lined with foxgloves and found a 'Grove Inn' where the landlord told us that the local church was built on the site of the village's sacred wood. In the church a 'celtic pillar' was used as its doorstep. (For trampling on paganism?) The eighteenth-century chancel ceiling was painted in a baroque, mystical, cosmological style. I lay on my back in the chancel to photograph it.

In the next village, in the visitors' book in the church we found, to our surprise, the name and remarks of Maia, written the day before. She had hoped to join us that day but had to cry off due to work commitments; instead she had made her own spontaneous exploration of the villages the evening before – and now had in a way joined us.

Kris and I became suspicious about the absence of accessible woods and public footpaths; was there a tradition of prohibition here, to stop the people returning to the old altars? It was only on making our way back to the tiny railway halt to catch the train home that we finally found and chalked our sacred space. Tired and dehydrated I called at the Old Station House, now a private residence, and the lady living there kindly filled Kris's empty water bottle with water cooled in her refrigerator. Placing the full bottle on the tarmac of the railway platform, we chalked around it. Then drank the water together. Leaving a circle of generosity.

Take a packet of salt or a piece of chalk and outline a new sacred space in the ruins of an old one.

## Excellence does not have a centre

Go to some Visitor Centres without passing through to the main sites, enjoy these airport terminals of Hy-Story as significant non-places in themselves. (The term 'non-place' was coined by anthropologist Marc Augé to describe anonymous, generic spaces like airport terminals or the rooms of international hotel chains; by his assertion they are too anonymous and globally homogenous to register as places at all.)

## Final countdown

Are you the last of something?

Harry Patch was The Last Tommy. Someone will be The Last Holocaust Survivor, The Last Bolshevik (or are there none left, did the last ones disappear unnoticed under Yeltsin or Putin?), The Last Nazi, The Last Windrush Passenger, The Last 9/11 Eye-Witness, the Last of the Vietnamese Boat People.

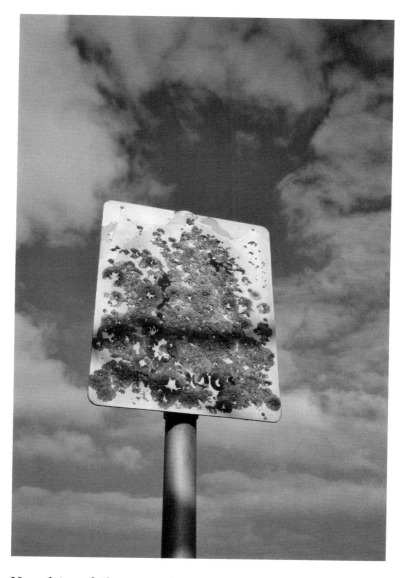

Vast plains of silence condensing down to stress a single face.

What vast obligation – to be carried alone – might convulse yours?

## Stem Cells

The work of counter-tourism is the re-making of heritage-space, not by making more exact representations of the past, but by fanciful -mapping.

Begin this alchemy by exploring old sites in the hyper-sensitised manner of the tactics and then pass on your pleasure by mapping it onto a description of the heritage landscape. Fanciful maps can be guides like this one, sharing tactics invented during explorations. They might be assemblages of images made from hundreds of pieces cut from heritage trail leaflets and tourist brochures. They might be drawn by children. They might be 3D models made from lollipop sticks or tin models of the Eiffel Tower. (In Harleston I was two years too late to find the ten-square-metre model of the Temple of Jerusalem made by Thomas Abrams, and could only stand and enjoy, perhaps more than finding it, the space it had once been displayed in.) They might be videos, or stories you tell in a pub or a café or a mosque.

Make a map in conflicting scales, create a legend (the key to the symbols on your map) that is partly random. Show your emotions on the map in the shape of contours, the lines closer together when most intense. Mark any revelations as landmarks. Show any examples of history poking through the surface and record the exact locations of the entrances

to the Underchalk. Forget to mark fences or walls. ⊕

For more ideas plunder political maps like 'The Institute For Infinitely Small Things' map of Cambridge, Massachusetts on which places are renamed after new and ordinary heroes, like Emma Kay's world map which she drew from memory, scientific maps which by dint of their 'scale' or subject tend towards awesome lyricism or surreal absurdity, maps of Cosmic Microwave Background, or dialect maps that slice up countries like a butcher's chart, separating 'jimmer' from 'hinge', 'leery' from 'hungry', 'bandy-legged' from 'bow-legged'.

Search out ironic maps like the 1937 Whimsical Map of Hollywood on which stars' homes, studios and the scenery on the lots all appear equally flimsy. Or pseudo-scientific maps like those mapping the sightings of the Count of St. Germain over hundreds of years, or the pre-modern mapping of 'phantom islands', where the never-to-be-found-again phantoms drift ever further out to sea.

There are maps illustrating fiction, like that for Alan Sillitoe's novel *Travels In Nihilon* on which nonsense place-names are jumbled with reversed names like Yort. Or those for Middle Earth or Narnia. All can be ransacked. (There are books about such mapping – *You Are Here*

---

⊕ A model for any town is that of Lud-In-The-Mist (from the novel of the same name by Hope Mirrlees), where the inhabitants chose to pull down the defences they had once erected against Fairyland and to let their dreams come marching back in.

and *The Map As Art* by Katherine Harmon, *Strange Maps* by Frank Jacobs, and *The Lie of the Land: The Secret Life of Maps* published by the British Library.) You could create a new guide by cutting up this one. I would take it as a compliment...

The maps of your visits should only be fully understandable if the reader acts them out, a script for the next performance of the site; a means to creating a repertoire of repeatable and recountable counter-touristic visits.

## Wet brainer

Visit a maritime museum as if you were in the concourse of London's Liverpool Street Station. Take a packet of salt or a piece of chalk and explore, under a scorching sun, a series of Devon villages whose names slice up countries like a butcher's chopper, separating 'jimmer' from 'hinge', foxgloves from 'hungry', 'bandy-legged' zombies made from lollipop sticks or tin models of the Eiffel Tower. (In paganism?)

**Excellence does not have a salty centre**

## Use trees as museums

The *Stock im Eisen* in Vienna is a piece of spruce trunk thick with nails, left by travelling smiths.

Wrights & Sites, of which I am a member, filming next to a car park, chanced upon a tree decorated with a thousand used condoms.

At Bentwaters USAF base, at the end of their tour of duty, US servicemen would throw their boots into a particular tree.

## Quest

To make an extended counter-pilgrimage, say of a couple of weeks in duration, and mostly on foot, will give you a legacy on which you can draw for years to come – a journey like this is a treasure chest of risks, disappointments, surprises, mistakes, metaphors, scenarios, tactics, revelations... to savour, and to share sparingly.

If you seek a model, check my account of a search for one-hundred-year-old oak trees, following the route of an acorn-planting engineer a century before. (*Mythogeography*, Triarchy Press, 2010, pp. 20-108.)

Top tips: on these quests you will almost certainly need a

rucksack, good boots and blister plasters – after that it's up to you. If you're worried that you'll look too much like a pilgrim, relax: people will want to give and tell you things when they know you are on a mission. Have a clear quest, explainable in a sentence. Remembering always that it is only the starting point for going off at tangents.

## Stem Cells

The idea that the past was superior to the present is dominant in one ideological strain (Nostalgia) while the opposite point of view dominates in another (Progress) – the two have secret affairs, and this makes heritage sites places of intrigue.

## Morgawr

The twentieth-century magician Doc Shiels conjured an ancient Cornish sea monster with an incantation and a camera. Use a camera and a few well chosen words from the appropriate literature to fabricate a sunken city, Cthulhu draped around its towers – a strange new New York.

*www.countertourism.net*

*This is the website where you can gather and share new counter-touristic tactics and pass around the soft ammunition for the gentle takeover of heritage space.*

*Join the discussion on Facebook at 'counter-tourism' and on Twitter at twitter.com/CounterTourism.*

*Set up your own website and we'll share the link to it on ours. You might find useful models in the 'carding sites' DarkMarket and CarderPlanet – where criminals once traded credit card details and (often freely) shared the expertise needed to create a shadow banking system (counter-tourism is a shadow heritage system). DarkMarket, appropriately for a counter-tourist model, was administered by an undercover FBI officer and CarderPlanet was given free rein by the KGB... oops, FSB (on the understanding they left Russian accounts alone). Everything is interwoven and we aspire to a similarly complex relationship with the heritage industry... So, come, step through the mirror...*

## Entrances and exits

Take a curtain with you. Perhaps a transparent or translucent one, a ghost sheet, for sweeping in and out of rooms... but here's the horror: the curtain (knowing its job) sees through you. Hiding everything else, it exposes whoever uses it or looks upon it. So handle it carefully, because wherever you take it, you create backstage wings, dressing rooms and property stores, a behind-the-scenes of the site's dreams. Those places where the site stages for itself what its visitors are to it.

**Many of the tactics here involve collaboration and cooperative devising – not rocket science, but there are simple principles that can help you avoid the deepest pitfalls: try these tactics with people you like, say 'yes' more than 'no', try things out rather than guess if they'll work... remember, short of someone getting badly hurt, nothing can go wrong; every failure is useful material. If consensus doesn't work for you, devise a structure that allows you all to work around an agreed theme, but each in your own way: define agreed 'compartments' of time and space, within which each of you acts unhindered and no-one controls the result.**

## Free lunch

The eighteenth-century freemen of the rotten borough of Dunwich were provided with grand feasts of free food and drink in exchange for their votes in Parliamentary Elections. The freemen represented these bribes as "traditional town dinners". What crimes can you reinvent as Tradition?

## Forestry omission

In the UK in 2010 there was an outcry from an influential section of the population when a newly elected government suggested 'selling off' the national forests; yet anyone who walks in the UK's mostly dense, dark, often now coniferous forests knows that they are largely deserted.

What the upper-middle class really wanted to save was not the scratchy, silent reality but an image of sentimental oaks that blocks out the view of the post-colonies in the cities.

Set aside a forest for just one person to walk in for a day; a

person who has suffered exclusion and persecution. Then the next day, gather in immense numbers in the same forest, for walking together in small groups to discuss the crisis of solidarity.

Or visit a wood and attempt to trip over as many roots as possible, while mentally shedding as many of your own as you can. Next day visit grassland and reconstitute your past as a network of rhizomes (creeping rootstalks that separate into parts, each one able to produce its own plant).

> **Try some of the tactics again – but set yourself a time limit – thirty seconds, five minutes, three months.**

## Stem Cells

Once familiar with a few tactics, and with an intuitive grasp of the principles, you should be able to spot portals that open out onto telling spaces, or wormholes that shrink time and space, and step through. A sideways pace here, a difficult question there and you're into the 'Underchalk', through the curtain, and along the holey-space.

Once the principles of the counter-landscape are grasped, it is only ever a blink away... somewhere to get lost in for a day, or to step in and out of while in mid-conversation.

At Littlehempston railway station Emma and I somehow contrived to miss the steam train, immersed in the textures of the platform, despite arriving 20 minutes early... lost in a landscape that wasn't even running according to the timetable.

When someone comes on a visit with me for the first time, they usually say, "I saw things I've never noticed before". Not because counter-tourists are special, but because the landscape that the tactics of counter-tourism

give access to is special. It provokes these places to express their 'inner apocalypse', the catastrophe suffered by everything that time passes by and everywhere that time passes through. The truth that heritage morticians (sorry, managers) seek to cover up: that the past is dead. The older the heritage, the deeper the trauma of its passing; as creatures made from stars, these catastrophes happened to us long, long ago and what we can experience now, if we will train ourselves to see, are their revelations.

This makes us archaeologists of contemporary ruins, agents of something Evan Calder Wiliams has called *salvagepunk*: in "a *kaputt* world, strewn with both the dream residues and the real junk of the world that was", *salvagepunk* is the opportunity to punch your card for "the hard work of salvaging, repurposing, détourning, scrapping".

Counter-tourism would like to flatter itself with the thought that it is a *salvagepunk* in the post-industrial landscape of pseudo-heritage: rooting around and re-building from tourism's ruins.

# Lies of the Land

*Counter-tourism and its tactics originate from the principles of mythogeography – a way of understanding the world and acting in it that privileges space and place above all else. So, it's not surprising that counter-tourism is similarly biased. When in doubt, it looks to the place to provide the answers. Before this* Handbook *moves on to the second and third stages of counter-tourism – **interventions** and **open infiltrations** – here are a few ruminations on the productive roles of place and space in counter-tourism.*

## Bed

Close to the centre of Plymouth, a dried-up, fake, miniature canal runs between palms, stone lions and ruined chessboards – part of the excess of post-war regeneration – like an abandoned archaeological excavation of a civilisation that never existed. If you are willing to find your way around a few walls, you'll find unreal places everywhere – the road to nowhere at the plague

village of Eyam in Derbyshire; Tyneham: "the village that died for England"; Chicago: a fake Palestinian town in the Negev Desert used by the Israeli army; Willoughby: a railroad stop in the First Series of *The Twilight Zone*.

## On the square

Look out for the symbols of Freemasonry (block, plumbline, set square, compasses, twin pillars, chequerboard). In English towns they are a blessed relief from the commercial banalities of cloned High Streets. Rejoice in their everyday esotericism (mostly ignored and, when noticed, suspected).

## Big Flame

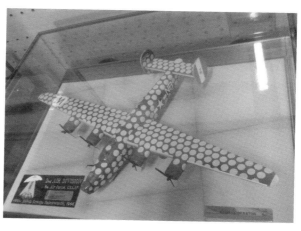

There is a conspiracy-narrative concerning events during the Second World War that occurred on a stretch of deserted pebble beach called Shingle Street on the east coast of England. The story wobbles between a secret, large-scale German invasion, a small incursive German force and some sort of local Allied exercise; whichever it is, the denouement of the tale is always the wholesale incineration of those involved by ignited gas pumped into the sea in hidden pipes, consuming everything in a bubbling ocean of flame.

A few miles away, at the Woodbridge RAF base, an immense runway was constructed during the war for the use of aircraft in difficulty, damaged in raids over continental Europe,

returning under the less-than-full control of their crews. In the event of mist or fog adding to a pilot's difficulties, FIDO (Fog Investigation and Dispersal Operation) was triggered and, to burn off the miasma, sheets of flame from the vapours of petrol pumped at a rate of 100,000 gallons per hour were thrown up around the runway.

While both stories are intriguing, which is the most _____ (insert your own value judgement here)? Credible? Exotic? Meaningful? Significant? Symbolic? Revealing? It seems impossible to escape from what historical narratives can do – reveal, symbolise, summarise, upset – in order to get to some passive thing that might be described as 'history itself'.

Or have you learnt already that certain questions don't need to be asked or answered?

Next time you visit a heritage site take a box of matches and observe the site through a tiny sheet of flame.

## Simulacra now

Wander film locations. Shelter under Kevin Costner's tree at Sycamore Gap on Hadrian's Wall.

Search out locations that only survive in their movies, like the site of the Shell Haven oil refinery on the north bank of the Thames Estuary, long demolished; but still preserved, in its matte-adapted form, as the doubly inauthentic 'Moon Project' of Val Guest's *Quatermass ll* (1957).

## The empty space

At 'Chudleigh Rocks: Gardens, Caves, Nursery and Tea Rooms' there is a 'History Hut'; a shaky garden shed full of bric-à-brac: Chinese takeaway menus from the 1960s, pre-war Conservative election posters, early twentieth-century farming implements, a Burmese temple sculpture damaged by US army 'rifle practice' prior to D-Day, and various stuffed animals, all rippled by the

damp and entwined in the ivy that has entered through the roof. There is a semblance of labelling, interpretation and categorisation, some artefacts have been carefully framed and displayed, while others are piled under tables in heaps. Only in degree and size is this collection any different from those of the great national or city museums – possessing the same conflations, selections, juxtapositions, concealments, suppositions, invasions and cavernous gaps.

Look out for history huts, and remember: museums are just big sheds.

## Z Worlds

Look for metaphorical heritage in zoo-botanical-architectural sites:

> *Was looking at your Z World⊕ and remembered a tip. If you ever go to Leamington Spa and see the Elephant Walk, there is another cool thing there. At dawn, or close to – early and dewy – the bridge on Dale Street over the River Leam has a spider street between its arches. It is Victorian ironwork and a spider has taken up residence in each arch. Some are immaculately kept homes, pristine and symmetrical, others are a little more neglected, and others still look like half-derelict shambles owned by stoners and squatters. Society in spider street form. Humdrum and magical. Nobody ever notices, but it's special. I used to go past it every day en route to work and I loved it. Sort of an arachnidan version of the nearby Georgian terraces. And then in nearby Victoria Park you'd have a sort of Glastonbury sprawl of webs over the lawns.*

(Message to Mytho Geography on Facebook from Anna Morell.)

---

⊕ The writer was referring to a mythogeographical category of place: "Z Worlds: ...self-contained worlds confined within a small area. They can be found in discarded boxes, in sheds, in abandoned rooms, in rock pools, in shop window displays, in decrepit horse troughs, on lichen-covered walls... in the corners of clubs. Anywhere a small space has become a self-contained universe."

## Wounded

On Herm (one of the Channel Islands just north of France) an ancient menhir was broken up and its parts used in the making of the island's dry stone walls. A similar fate befell many of the stones from the henge at Avebury (part of the huge complex of Neolithic sites including Stonehenge), splintered by huge fires set around their bases. Were these markers wholly destroyed? Or was their meaning dispersed?

## Psychodemiurgics

The intelligent and emotionally literate ghost movie *The Awakening* (2011) was filmed partly at Manderston House, an Edwardian country house in the Scottish Borders. The property is open to the public twice a week in the summer. Watch the movie, then visit the house. (If you can't get to Scotland, find your nearest equivalent site; the more distant the comparison, the better the imaginative leap.)

Is the place already haunted by the visit you've imagined making? Do scenes from the movie re-run there? Is there something that the cameras of other visitors detect that yours doesn't?

Given the collaborative but hierarchical and technically complex nature of commercial film-making, much that is imagined for a film is lost before it reaches the final cut. As theatres are haunted by characters without the actors to realise them, so lost movie ideas haunt their locations long after cast and crew have moved on.

The writer of *The Awakening*, Stephen Volk, described to me two of its lost ideas: a ghost seen upside down through the lens of an old box camera, and snow falling indoors.

Visit other movie locations and project onto your mind those scenes you imagine were lost from the final cut. Act them out. Imagine snow instead of carpets. See it all, upside down.

## Modern Ruins

Battleship Island (Japan), the Walled City of Kowloon, Bannerman's Castle on the Hudson River, 'Wonderland' (a derelict theme park outside Beijing that never opened), Prypiat (the city of Chernobyl), St Peter's Seminary at Cardross, Sutro Baths near San Francisco (careful, visitors have been swept away and drowned, others haunted by the Giggling Ghost), Saythorn Unique in Bangkok (straight from building site to ruin) ... these are the architectural equivalents of the ruins described in Percy Shelley's poem 'Ozymandias', remnants of a once all-powerful emperor's temple, with its motto "Look on my works, ye mighty, and despair" disappearing into the sands of the desert.

## Life in the round

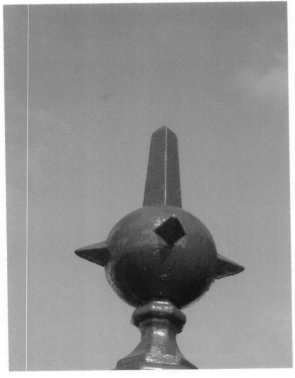

Keep an eye out for any metaphorical or symbolic space in heritage sites. You may spot clues in the following: government and company insignia, the shape of electricity pylons, chequerboard ground plans, people acting as public ornaments, advertising, heraldry,

anything quoted at third or fourth hand or more, these may be referencing a complex system of belief, a mystical order of symbols or a twisted history of pseudo-events.

You may not realise that you are in a metaphorical or symbolic space as you play Hopscotch (Roman military agility training), dance the Hokey-Cokey (see above), fill up your vehicle under the pecten (pilgrims' badge) of Royal Dutch Shell, find yourself crossing the road to Santiago de Compostela or absent-mindedly making sand castles.

To encourage you to keep searching and asking, you might take an informed look at the National Trust property at A la Ronde in Devon. This sixteen-sided house is presented to the visiting public as an eccentric, but essentially domestic and private space designed for (and possibly by) two slightly wacky (they were unmarried) and reclusive (no, they weren't) female cousins at the very end of the eighteenth century. The unusual materials (shells, sand, feathers, broken glass, lime and smashed porcelain) used by the cousins and their companions to decorate the house and the strange seaweed wallpaper patterns that dominate its tall eight-sided central room are passed off as innovative, yet conventionally female, ornamental materials; decorative meaninglessness. However...

...a little research reveals that these educated and articulate cousins came to this house after a decade on the road travelling through revolutionary Europe, visiting classical sites and collecting fashionable neo-classical and sublime art (prints of Piranesi's engravings of the ruins of Rome, for example) and bric-à-brac. It also shows that they inherited the wealth to build the house and display their gatherings from the profits of the family's glass factory in Lisbon (destroyed by earthquake and tsunami – the devastation of which rippled through European culture and inspired Kant's essays on the Sublime) and from the family's concrete factory that provided much of the material for Lisbon's reconstruction.

Family legends reinforce the apocalyptic imaginary of the place, its numerous references to the fall of civilisations, fragments of long dead cultures (obelisks, urns, cedars), an emphasis on the conversion of the Jews and a return to Israel (the house had its own chapel complex for the Christian re-education of Jewish widows, the oak trees in the grounds were only to be cut down to build ships for the return of the Jews to Israel) as the prologue to God's kingdom on earth. The everyday materials used in the decorative friezes reference the detritus left by the tsunami, including broken glass and some of the constituents of concrete, while the tall central room places the visitor under the waves. If you walk out of the house – imagining the former 'wild walk' that once guided (and unnerved) the visitor to the lawn – you can find a small rise in the lawn, an eighteenth-century viewing platform, and from there look across the property's ha ha, over the estuary of the River Exe to what in Devon passes for a landscape of dread, of reasonless fear... the vista looping back to tsunami, Lisbon and the sublime.

Now... you can choose at this point to do what the 'heritage professional' tends to do and find a rational, domestic, sociological or accidental root to each of these elements at A la Ronde, nod sagely and concede that 'of course, it is a valid point of view'. OR you can adopt the counter-tourist's playful paranoia and assume that there is always more to things than meets the eye. If you adopt this hyper-sensibility, metaphorical space will manifest around you as fields of cultural energy.

Once sensitised to the metaphorical-geography all around, you will find that part of your daily life has become a pilgrimage through heightened spaces, walking the physical terrain while animating the mental terrain at the same time, experiencing fantastical-geographical things while contemplating your supper.

## *Id*entity

The neatly mown lawns around castle ruins make for a strange mix of redundant military fortification and domestic back garden; two places we try to tell ourselves have no connection – but deep down in the *id* of the heritage industry they do.

## The importance of small things

Arriving in a small town, early one morning, desperate for some breakfast, I stepped into a small tea rooms and antiques shop; the one ran into the other. The sort of place I would never normally dream of visiting. I was the only customer. All the table accessories were pink. Ready to sneer at its tweeness, I became increasingly aware of how vibrant everything there was. A thick glass goblet for my fruit juice, a very thin handle on the coffee cup, enormous knives and forks, and an elongated stem on the coffee pot. The whole tea room and its hinterland of old things was a machine for de-familiarisation; I experienced familiar things as if for the first time – tasted the bacon and eggs as if I had never eaten breakfast before, each element distinctive and rich. Objectively, the food was unexceptional, and the place was a cliché – but that morning it became a setting for a ritual testing of the senses, and I fell in with it.

## Yuk

In Exeter there stands a large 1960s modernist-style department store. In 1987 it was voted one of the Top Ten ugliest buildings in the UK in a poll published in *The Times*. The building is far from deeply beautiful, but the relation of its parts is pleasing. Often criticised for being unsympathetic to its surroundings, as it would be if it were sat on a mediaeval lane, in fact it rather puts to shame the immediate post-war and 1980s nonentities close by.

At the other end of the High Street is a mediaeval cathedral. Built in Romanesque style, its nave was hauled down in order to be rebuilt as a fabulous gothic edifice. But the towers were left in place, their Romanesque windows and arches only partially converted – a real dog's dinner of a redevelopment; nothing could be less sympathetic to its immediate context. Needless to say, the building is one of the city's chief tourist attractions.

The most privileged objects of heritage and antiquity are treated like scenery in a mass hallucination, beyond questioning and

subject to a besotted gaze; as if tourists should behave like the loyal mums of serial killer sons. (Ironically, as this book goes to press, the modernist building is about to re-open after partial rebuilding; its harmonic massing ruined. Now just as jumbled as the cathedral.)

## Beached heritage

Brunel's Atmospheric Railway ran without an engine on the track, its silent-running carriages powered by the pressurisation of air in pipes between the rails. The system was closed down in 1848, but the tower of one of its pumping stations still stands in a Torquay car park, part of a fruit and veg wholesalers.

*Der alte Schwede* is Hamburg's 'oldest immigrant'; a 217 ton Småland granite boulder that sits now on the bank of the River Elbe having arrived during one of the great southward movements of ice either 400 or 150 thousand years ago.

Once you become sensitive to these 'erratics' you will begin to navigate a landscape from which such anomalies, large and small, repeatedly pop up.

## Mutliple space

On a nostalgic steam railway trip Emma and I found a goods van that was being used as a buggy park, had been a Santa's grotto and still had two wreaths on display from its use the day before as the bier for a deceased station master's final journey. Look for the different layers of a site in motion around each other.

In some heritage sites the multiple layers at work are so lively – absurd, political, poignant, sublime – that the meanings of these sites simply refuse to be pinned down. These are exemplary sites for sensitising adventurous visitors to the multiplicity of layers. Such sites might include the Palais Idéal at Hautrives, the Winchester Mystery House near San Jose, the sunken city at Dunwich, Bory Var at Székesfehérvár, and even the little

Walnut Museum near Castelnaud where everything tries so hard to convince the visitor of the virtues of a nut that eventually a nightmare vision of a world made entirely of walnut starts to form.

Make your own list and share it.

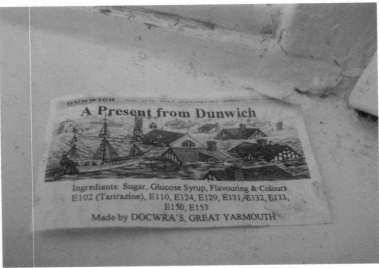

# Using the Tactics

## Photo essay

Photo: Steve Mulberry

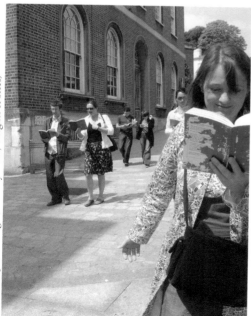

Photo: Stephen Hodge (Blue Boy Walk, Wrights & Sites)

*"Thank you for such an inspiring day... I am left with a feeling of having been 'away' somewhere, time extending rather than the more normal experience of time shrinking and running away from me!"*
(Eleanor)

*"I can honestly say I saw things there that I have never noticed or seen before, thanks to your brilliant way of looking for and at things. I also feel there is much more to discover now, having assumed I knew the place pretty well (always a mistake – smugness!)"* (Ruth)

Photo: Mark James

*"I think something happened in Somerleyton. I came back looking at my journey home differently. I felt a bit like a detective. Or maybe more like that guy from the Bourne Identity films. I noticed it even in the way in which I recounted our day to my husband. Strange - but when I looked at one of your tactics about taking on the feeling or power of the shape you walk - it seems that somehow Somerleyton's lack of obvious centre left me seeking, searching one... running back to the train station... I seemed to see a lot of doors closing (car doors, front doors) or animals just scurrying out of sight. That feeling of 'something is hiding from me' stuck around for a few days. I even continued wearing my mac when it was not necessary."* (Lorraine)

(Note: where not otherwise credited, the photographs in this handbook were taken by the Crab Man on the cheapest camera available from a High Street chain store.)

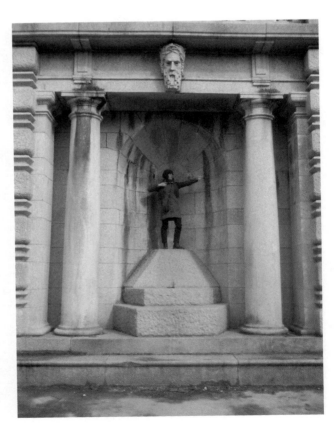

# Interventions For Counter-Tourists

*The key principle of any intervention in a heritage site is
doubleness – it is both for its own sake, and for provoking
something new. Whatever it is, it is best when made and
given freely and with as few obligations as possible; a gift,
inspiring or obligating its participants or recipients to give
their own. For this reason counter-tourism loves artists, but
not the market in their commodities. Counter-tourism likes
an art that involves everyone in the exchange. Counter-
tourism is not about buying and selling Hy-Story, but
making it.*

*Like the movies, counter-tourism may not fulfil desires
so much as suggest what desires can be. That is what
artists and activists can do for counter-tourism. It
doesn't need opinion-leaders, but desire-formers. Its 'art'
is an intervention rather than a production; not about
representing what is, but acting what is not, and what is not
yet and welcoming everyone onto the fabulous waste land.*

## Five second holiday

For years the garden
of 'Bernadot', a small
bungalow next to a busy
arterial road on the edge
of Exeter, was a stage for
shop window mannequins;
dressed in various exotic
and erotic costumes,
they saluted the seasons,
anniversaries, sporting
events and red letter
days. Transform your
front garden into a visual
almanac.

## Four... million!

Build a crazy golf course. Base the obstacles for each hole on different aspects of heritage –

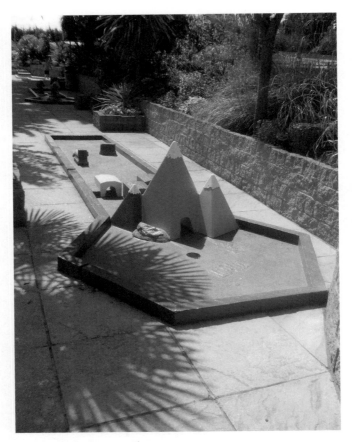

hole 1: failed messiahs
hole 2: mass extinction events
hole 3: holes
hole 4: forgotten technologies (Damascus Steel-making, for example)
hole 5: derelict sites of the Japanese sex industry.

You get the idea...

## The loved one

In gift shops and Visitor Centres hold spontaneous services to worship the Past, give thanks for accurate facts, and pray to the Unseen Trust.

## Revival

Under cover of a blizzard of nostalgia, revive anarchic traditions: the election of boy Bishops; Skimmerton Riding (where it had morphed from drumming out of town to riotous transvestite displays); Exeter's eighteenth- and nineteenth-century November 5th celebrations (which began with anti-Papal performances and then progressed to burning the banks later in the evening).

## CANDY FLOSS IS FOOD FOR THE BRAIN!

In the window of Luigi's sweetshop near the seafront at Weston-super-Mare there is a photo of the premises (already then a sweet shop) in the 1920s, a sign in its window reads: "EAT MORE SWEETS AND LIVE LONGER". This might serve as a model for new signs

of recently recovered forgotten knowledge:

EAT MORE CHIPS AND BECOME MORE BEAUTIFUL!

GAZE IDLY AND UNDERSTAND THE PAST!

A RIDE ON A BUS IS A TRIP TO THE STARS!

DAY-DREAMING *IS* ROCKET SCIENCE!

## Holding the mirror up to ridicule

Go to a re-enactment event. The sort of 'Living History' event where, in England at least, people come dressed as Saxons, Romans and figures from both sides of the Civil War. Where, if you are lucky, you might get to see a Brunel on stilts. But nothing more recent than Victorian. So rather than 'Living' this History seems to have died around 1889.

Book a space at the re-enactment event. A room or a tent or a pitch. Pick a day a couple of weeks before the event. Record, make notes, film everything you do during one hour of that day. Then re-enact it at the event, as accurately as you can.

After the first hour begin to re-enact that hour of enactment, after half an hour stop and begin to re-enact the half an hour's re-re-enactment, after quarter of an hour stop and re-enact that quarter of an hour's re-re-re-enactment... and so on... this way you will fold time into ever smaller sizes until you are able to put it in your pocket and walk away.

(Just a thought – how long should we wait before re-enacting a Civil War? In Spain the first Civil War [1936-9] re-enactment society, La Columna, was formed in 2000...)

## Banksy in 3D

Create anachronisms and leave them in museum cabinets.

## Damian

Make and market a grimoire (a handbook of spells) for invoking your local heritage site's demons.

## Souvenirs

Where gift shops sell or display exotic trinkets, particularly those that are objects of minority belief (Green Men in cathedral gift shops, cuddly fabric sharks at aquaria, toy UFOs in science museums), create a liturgy or ritual for them, then discretely process into the shop – treat the simulacrum space as a real one – unobtrusively leave offerings, messages, consult the objects. Be subtle, help the objects themselves become difficult for their retailers.

If you find any real power in these objects – or are disappointed by how little significance there is to them – make some simple invested objects of your own; ones that represent a generic feeling or atmosphere. Then, release them as guerrilla-things into gift-shops or gift them to friends to carry.

If you are pleased with the effect, try something excessive; a souvenir capable of rattling its owner. Two useful models for this are the Guernsey Occupation Sites Puzzle and the Before and After Taliban Card. (These are genuine souvenirs!) The first is a map of Guernsey on stiff card with indentations at the sites of key Nazi military installations on the island, into which the purchaser seeks to roll small coloured plastic balls; the map is slightly warped making the task almost impossible and provokes the thought: 'a pity it wasn't as difficult as this for the Nazis'. By tilting the Taliban Card one can see one of the giant niches at Bamiyan (Afghanistan) before and after the destruction of one of the two Great Buddhas in March 2001 – before and after, before and after, before and after...

It would be easy to put the unusual qualities of such souvenirs down to 'bad taste', but most likely they are the results of trying too hard. Rather than consigning their like to the graveyard of kitsch, recruit similarly excessive positive intentions for future provocations.

## Bunting

Given the mass migrations that climate change will bring, develop historic buildings as centres for mass welcoming.

## Obscure cameras!

Set up empty frames with the sign:

**'Photograph only through these frames, please! Leave other views to the eyes! Thank you. By order.'**

## A gem – empty space (number 2)

Wind machine.
Sound effects.
Chain fences.
Spot lighting.
Hand cleanser.
Plastic slip-ons
around the shoes.
Viewing platforms.
Information
boards.
Finger posts.

Assemble these around a site, with nothing of any historical
significance at the centre. (And see how difficult that is!)

## Crafty

Slip your own subversions of tourism information videos (see
'Wish You Were Here?' www.bit.ly/crab221 for an example) into
the Tourist Information Centre's dvd player.

## Drive in

Make a supply
of Fast Heritage
objects: stocks
on wheels, lych
gates on rollers.
That sort of
thing. Create
Fast Heritage in
the mall, on the
metro, at the
game.

## Misled

In Rendelsham Forest, I stumbled for almost two hours along the three and a half miles of 'UFO Trail'. I was alone in the forest. I'd been told of a white deer in the forest. I walked quietly in hope and then anxiety. The Forestry Commission's kiosk was closed, so I had no trail leaflet; I was navigating by the markers.

At the numbered points I could only imagine what might have happened or been imagined to have happened there. An evocative double inauthenticity. I photographed the sky at each stopping place. I noticed possible landing sites. I found a strange deposit like angel hair. As I ploughed on and the trail seemed never to end, I began to imagine being confronted by a giant white deer, twelve feet tall with a massive spread of antlers, when a huge silver figure suddenly cut across my path, half blank head like a faceless mannequin and half a Nordic Dan Dare – a trick

of the light, but for a moment I saw it distinctly, as tall as a Polar Bear reared up (like the stuffed ones at nearby Somerleyton Hall) and dressed in a silver jump suit.

I wondered at the signs warning dog owners of the strange and sudden deaths of so many pets there. And later, I saw the white deer for real. (I did!)

Work out some routes to be signed as walking trails. Advertise them and lay them out with numbered markers. Make a ghost trail, a tragedy trail, an exploitation trail, a Sasquatch trail, a comedy trail, an atrocity trail, a renaissance trail, a democracy trail... whatever trails you wish. Produce leaflets explaining the generic significance (real or not) of each marked and numbered spot. Every now and again, switch the trail markers around, from one route to another, but keep the same leaflets. Exchange markers and leaflets with counter-tourists in other parts of the city, other parts of the country, other parts of the world.

## Ostrich rampant

Create your own absurd coat of arms.

## Neo

Walking through the villages and small towns of England you will often see private houses named The Old Police Station, The Old Institute, The Old Chapel or The Old School House. Make signs for The Old Welfare State, The Old Web Server, The Old Video Shop, The Old Public Library and The Old Public Space.

## Rationality

At Coverhithe, on the Suffolk coast, is an unusual church. This modest seventeenth-century building has been constructed from, *and inside*, the ruins of a far larger fifteenth-century one, the small chapel more suited to the needs of its small village congregation than the grandiose vision of the wealthy incumbent who built the earlier one.

What smaller things might be constructed from, *and inside,* the ruins of the Arc de Triomphe, the Gherkin, the Palace of Westminster, Monumento Nazionale a Vittorio Emanuele ll, Bayreuth Festspielhaus...?

## Window on the world

Use the changing rooms of charity shops as small theatres; the shops' arrays of clothes and commodities will serve as your costumes and props. Swish back the curtain, stage a short performance, collect donations in a hat or bottle (borrowed or bought from the shop) from your invited guests, and give the proceeds to the charity.

In the changing rooms of large or elite fashion stores, rig up a projection or a laptop display with footage of the workers who make their products. Create a theatrical tableau of a sweatshop scene. Then complain to the staff that a wormhole opened up while you were changing...

You may have noticed that this *Handbook* has changed gear... that many of these interventions may require preparation, even construction; sometimes on quite a big scale. If any of this seems daunting or too much like Art or Performance then forget those bits. Do what you're happy with – enjoy the more complicated projects as fictions and fantasies (some of them will only ever be that!) – just *do* the bits you enjoy.

Scale and style are very definitely not the main things here. Doing lots of the simple small things is probably the most effective thing of all. That and sociability and the things you change in your own head.

And even for anyone who *does* want to prepare the more complicated interventions, it's important to begin by casing a heritage site using the simpler tactics, the ones to be found nearer the beginning of this *Handbook* and in *Counter-Tourism: A Pocketbook*. Pick and choose. This is an abandoned candy store. The ideas here are for use, not for rent.

And if you're frustrated – you *want* to make one of these interventions, but you *don't* have the resources – can you shrink the scale? Can you make it happen more subtly? Can you, by very precisely placing a tiny intervention, commandeer a whole site?

Some mini-version (probably all the better for being so) can almost certainly be made from all the following suggestions; using just the resources that mainstream tourism already provides...

## Holly Wood

In 1933 James Hilton wrote *Lost Horizon*, a novel about an imaginary utopian community somewhere in the northern part of Southern Asia. It was made into a movie, starring Ronald Colman.

Hilton, who had never been to the area, called his utopia Shangri-La. The book and film provoked many public expressions of desire to find a real Shangri-La (a term which soon came to mean 'a thing that only exists in fiction').

After a competition involving various communities in Tibet, the town of Zhongdian has recently (2011) been re-designated by the Chinese Communist Party as 'Shangri-La' and is expected to develop now without conflict, without avarice, without conflict of identity. As all prefabricated tourism centres are.

Invent a utopia. The more idealistic and unfeasible the better.

Then invent a massive imaginary bureaucracy.

Send a request from the imaginary bureaucracy to numerous communities around the world inviting them to join in a competition to assume the name and lifestyle of your unfeasible utopia.

Who knows? If it works, then you can use your imaginary bureaucracy to propose all kinds of nonsenses: National Old Thing Day, meditational help-in-kind, symbolist logos...

## Anticipatory history

In, or just outside, a heritage site with plenty of footfall, set up a model for the redevelopment of the site; a board of some kind with the site broken down into a number of elements. Label the model's parts. When passers-by stop to look at the model, re-position the elements to reflect the arrangement in which the passers-by stand. So those that stop to look dictate the model. If they ask what it is or who is ordering this change, explain that it is an informal speculation and that nothing so far has been agreed, that all can have their say. They may want to move the elements or ask you to. Let them, help them. But allow the movement of the models responding to new arrivals to continue, so different forces are at work in different ways. Submit a re-design to the site's managers based on the final position of the pieces. (With thanks to Sarah Williams for this idea.)

*Hold on, if this is* counter *heritage tourism, why don't you simply immerse yourselves in memorialising the history of counter movements? The Levellers, the anarchists of the Spanish Civil War, Dada, Müntzer's Anabaptists, the Wobblies, the Spartacus rebellion, Solidarność, the Jacobins, the Haitian revolt, the Civil Rights Movement, Tahrir Square, Occupy, Edelweißpiraten, Umkhonto we Sizwe?*

**Counter-tourism constructs its resistance from the detritus of the powerful, from the waste bins of administrators, from the leftovers of whatever fad has just collapsed... at, and to, the side of rebellion...**

## Hush house

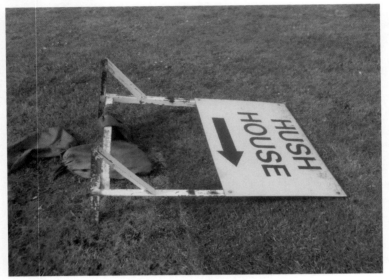

Lead covert guided tours in highly sensitive or heavily policed sites.

## Turf

Public art should be made by the public. Feel free to donate temporary additions to any work of art installed in a heritage or tourist site.

The lump of grass deployed by a 'crusty' on the head of a statue of Winston Churchill in London's Parliament Square gave the war leader an unexpected, but strangely appropriate, mohican.

# The Mis-Guided Tour

Photo: English Riviera Global Geopark

### What is a mis-guided tour?

I once led an entire conference of tour guides to the wrong restaurant for their conference dinner, but that is not a mis-guided tour, that is a spectacular cock-up.

A mis-guided tour uses the latent qualities of the standard mainstream guided tour, but rather than simplifying, clarifying and reducing, the mis-guided tour always maintains the multiplicity of stories and meanings in any one site.

The idea of a 'mis-guided tour' emerged in 1998 from the work of the site-specific artists and performance-makers Wrights & Sites.

Photo: Steve Mulberry

Working in a sensitive heritage site, earmarked for future development, we became aware of how the meaning of the space was being closed down and policed. We invented the mis-guided tour as a way of telling its many narratives and found that the form could be applied elsewhere.

Photo: Bryony Henderson

Using many of the attributes of a mainstream tour – commentary, guide, a prepared route, walking and pausing, pointing, anecdotes and potted histories, jokes and personal reflections – we adapted and disrupted these to create a tour that was not only multiplicitous in its stories but also in the ways it used the senses of the audience and engaged them with the route. Audiences would drink, eat, touch, carry and act out.

Rather than the simplified and passive site of the mainstream guided tour, the mis-guided tour animated its sites as rich assemblies of traps, uncontainable

Photo: Mark James

by 'standard' commentaries; provoking the latent excesses that lurk in every heritage site. We invented an unreliable and yet insightful tour guide-persona who could speak the fakes, mistakes and silences of the sites, engaging ironically and autobiographically with its many layers, peeling them back and drawing them out, bringing together fragments of performance and Hy-Story into a new kind of mix.

# Terrasse
## Le Donjon
# Boutique Médiévale

## Processions

Processions can be put together very quickly and effectively if the different parts of the procession are made separately and then only assembled during the procession itself. So, collectively, settle on a route and a theme – something from the Hy-Story of the route you've chosen – and divide into groups.

Each group takes responsibility for a different element:

> music
> objects (burdens or relics) for carrying
> chants for shouting or singing
> physical actions to perform during the procession
> banners and placards
> a ritual to be performed at a particular spot on the route.

Everyone is individually responsible for choosing a costume related to the theme.

Get everyone together twenty minutes before the procession. Teach everyone the chants. Line up. Then process.

The periphery of the march should interact spontaneously with passers-by and street furniture.

Photo: Katie Etheridge

## Appledore

Create for yourself a subjective signpost like Katie Etheridge's – different fingers of the post recording the number of miles to places of personal significance for you.

## Big trick

At sites of industrial heritage, agitate among the guides to form workers' councils.

Organise an international Heritage Strike in which, for three years, heritage sites will be locked down; one effect will be a dramatic expansion of heritage space, with heritage-hungry members of the public redefining everyday spaces as historical and furtively conducting archaeological digs in their back gardens under the pretence of gardening...

## Choo Choo

Commandeer the local tourist 'train' – that motorised fake-train with carriages that carries tourists along roads and pavements around a few designated spots.

Write your own audio commentary for the train. Have the voices of the audio argue and bicker and fall in love, tell secrets, spread rumours, uncover scandal. Change the route. Place something or someone outrageous by the side of the road.

When Alex Hanna made his 'Schou-Schou' train tour in Fribourg he had the train go through the local abattoir, and round and round a traffic roundabout outside a casino like a ball on a roulette wheel.

## Eroto-phys

Seek out the places in iconic heritage sites that turn you on the most. How does your arousal inform your understanding and 'feel' for the site?

Adapt Christian Nold's 'emotional maps' for the tracing of variable states of moistness in heritage spaces. Map historical orgasm clusters.

Change the calendar from A.D. or C.E. to P.C. (Post-Coital). Date things to historic sex acts.

## Art of living

By running lots of different tactics at the same time, or in a succession of parallel journeys, for a while – maybe a few hours or a few days – counter-tourism can become an 'art of living'. This can happen when the expanding range of your tactics and interventions, their interconnections, your routes through different spaces and the intensity of your encounters take the whole thing to a new level of hypersensitised living.

This isn't a 'way of life', or lifestyle, as such – it's not a search for a milieu or a 'scene' – it's an adventure based on disruption that lasts for a while and then is itself disrupted and returns to the everyday.

The GeoQuest of 2010 (made by composer 'Aeolian' Hugh Nankivell, seaside entertainer Tony 'Uncle Tacko' Lidington and myself) became just such an 'art of living' – through its encounters with elderly people in care homes, its costumes, its joining young children to hunt around in their playgrounds for rocks, glancing encounters in the street, mis-guided tours, spontaneous pavement and seaborne performances

and rehearsed evening shows, exploration and preparation, feasting and enjoyment, overnight stays in B&Bs, caves and private homes... crafting these things together, on the hoof, as a Quest.

After the third day, the Quest went from a timetable of separate events, to become an 'art of living', a free-flowing social life in transit; not necessarily exemplary in its parts, but in the way it moved beyond the sum of them, drawing more people to be part of it... you can watch a short film of it here – www.bit.ly/crab222

In a way a Quest is as intense as counter-tourism can get, though it can be entered into at any scale. It is not quite a pilgrimage as there need be no set destination; even its exceptional landmarks are for passing through. Nor is it a hunt with a specific quarry: thief, Grail, fox. If it has a quarry it is the bringing together of many things, many layers, many stories, many actions. Like a pilgrimage, its journey is heightened by its disruption of everyday life, by a special sensitivity to the path trodden and by an expectation of significance in everything.

In Nicolas Roeg's film *The Man Who Fell To Earth*, an extra-terrestrial, played by David Bowie, is shown watching a huge bank of TV screens all playing different channels – this is the 'alien' and heightened feel of the Quest. It means a sensitivity to, and a running sense of, all the layers of its space. However, counter-tourist-questors are not confined to a room of technology, but are making their way through many rooms and many technologies, keeping all the channels running while, by the motion of their journey, setting their stories in motion.

## Pause button

The mechanical figures on the Rathaus clock in Munich mess with the tourists that gather in Marienplatz.

The Rathaus bell strikes the hour, but rather than the figures beginning their mechanical dance, there is a considerable pause before they spring into artificial life. Time stretches. The crowd becomes distinctly uneasy, people shift from foot to foot...

... Construct devices for stretching time in historic sites.

Surreptitiously install an enigmatic object in a heritage site, placing an opaque sheet over it as if it were shortly to be unveiled. Perhaps add an oblique notice. Overnight remove the object, but leave the sheet.

Announce the imminent return of lost things: the Ark of the Covenant, the Dodo, the Amber Room, Blackbeard's booty, the Templar treasure, Atlantis, Ambrose Bierce...

Wait to see what turns up.

## Architecture

Design a new Tourist Information Centre in the shape of a huge funnel that ends in a tiny cubicle. This is to expedite the diversion of so many and varied queries to such generically similar pamphlets and portals. Then reverse the funnel.

## Get some friends together...

...and push castles.

## The Devil's Footprints

In Siobhan Mckeown's short movie, The Devil's Footprints – www.bit.ly/devil01 – a story emerges that is mythic: of a trail of Victorian technological innovation of a mostly military cast involving battleship designers, the inventor of the computer, mathematicians, radio communications pioneers and the inventor of the screw propeller. This story worms its way along a sleepy coastline on exactly the same route as a set of 'devil's footprints' that famously appeared in the snow in 1855.

Find the mythic trajectories of your sites. Film them.

## Authenti City FC

Find a low value heritage site and build an improved replica very slightly to the east of it.

Allow the original to decay while maintaining the replica.

Once the original has collapsed, cease repairs on the replica.

After the replica begins to show signs of collapse, build a replica of the replica slightly to the east of the replica. Maintain the replica of the replica until the replica has fallen... and so on.

Leave the original replica (you cannot imagine how much pleasure it gives me to write that) to fall into the hands of wild animals and urban explorers.

You now have the world's first nomadic heritage site.

**"Please, mister, can we have our myths back?"**

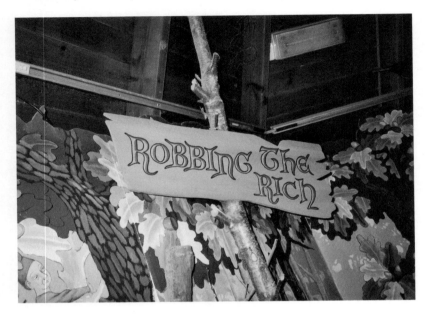

Visitor Centres are machines for the contraction, disguise, obscuring and hollowing out of the places they propose themselves as portals to.

But what if they were what they say they are? What if they really conserved the heritage?

What if, as well as selling Maid Marian keyrings or fridge magnets with jokes about Robin driving a Reliant, the staff of the Sherwood Forest Visitor Centre in Nottinghamshire were covertly organising robberies from the rich and distributing the booty to the poor?

## Crawlspace

Anywhere that promotes itself as a place "where time stands still", or as "an oasis of calm", or as somewhere "to escape from the rat race" or to "get away from it all" is going to be a place where behind the scenes the rat race will be at its bloodiest, the calm at its most fragile, the peace undeclared and the "it all" at its most inescapable.

Get behind the appearances and tap that tension. Use such 'oases' to test-drive your interventions.

## In the spaces in between

Infiltrate performers and audience, in the guise of ordinary visitors, into a well-visited formal garden. Pre-equip your audience and performers with radio-earpieces and broadcast a shared soundtrack. The performers then move to the music through the space in abstract patterns reflecting the formal shapes of the garden, behaving unobtrusively, so other visitors in the site will perceive them as nothing more than self-absorbed fellow visitors. The performance weaves through the other visitors, appropriating their flow to the performance. The soundtrack might address the philosophical grounds for the particular landscape design. After a while, add one performer in period dress from the time of the garden's design – this triggers the explosion of the formal pattern into romantic surges, the final one of which sweeps performers and audience out of the garden.

Organise a post-show party in the car park.

## Covert the top

Become an 'infiltration guide'. Inveigle your way into heritage sites and lead spontaneous mis-guided tours.

## Secluded Spot

Given the huge pile of human ashes I encountered recently on a walk through the watermeadows of a public park, I wonder when we should go the whole hog and re-introduce public excarnation: leaving the bodies of revered elders in beauty spots where relatives, admirers and casual passers-by can visit, view and pay their respects to the dwindling bones of former lives.

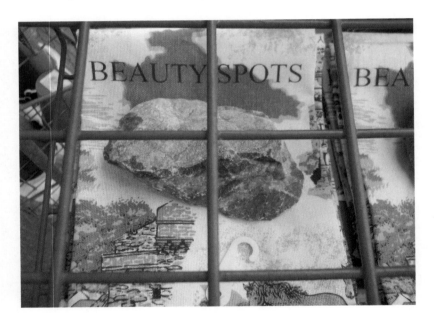

## Misinformation centres

Modelled on 18 Folgate Street in London or the Museum of Jurassic Technology in Los Angeles, (though they don't have to be 'life's works' – tourist misinformation centres can be simple and homespun), create bureaux of international mis-guidance.

Stock with localised mis-guidebooks, distribute guerrilla signage, facilitate extreme right-to-roam (the ambulatory equivalent of Wikileaks), and operate as a base for groups of 'mobile machinoeki' (mobile versions of Japanese walkers' pit-stops).

## Table for one

Create elaborate historical performances for single tourists who chance upon a portal you have specially prepared. This triggers a rehearsed extravaganza of brief but enormous impact. Sudden moments of epic labyrinthine revelation for just one person at a time, who are then gently but abruptly ushered back into the heritage flow.

## It depends what you mean by...

When members of the British Royal Family appeared on the TV show *It's A Royal Knockout* in 1987, acting as bogus-mediaeval aristocrats and speaking in inauthentic archaisms; it prompted some viewers to observe that something of the true nature of the

monarchy had been exposed. The double-inauthenticity of the TV game had peeled back a corner of the curtain.

A more recent manifestation of such revelatory 'historic costume' is the V mask from Alan Moore's *V For Vendetta* comic. These masks are based on the historical figure of Guy Fawkes; they transform a religiously oppressed, Catholic terrorist into an anarchist poster boy. They have appeared worldwide as part of the Occupy movement and on democracy demonstrations and anti-government parades in numerous countries.

Travesty expectations of the historic to make the future.

## Just the ticket

Set up a heritage site box office in the middle of nowhere and charge for entrance. (Thanks, Christine.)

**A box office in a wasteland is not a bad place to start on the final layer of this *Handbook*.**

**To get there I need to draw aside the vista and take a look at what is happening in the world beyond the heritage industry, and then look again as that world folds back into the industry.**

**So, a wasteland it is – for we live in an age of shock economics, catastrophe-capitalism, an era when markets look to deep economic crises and devastating natural catastrophes to renew themselves by stripping themselves down, homing in like drones on any opportunity to "start again with a clean slate". Shock and Awe, Hurricane Katrina, Toxic Loans, the Eurozone crisis, the East Asian and Japanese Tsunamis; such are the 'natural terrains' for these markets, impatient of negotiation and**

preferring always to "start from scratch", to import contractors, to replace infrastructures; always removing local and installing global. The theory-godfather of this market-shift is 'the end of history'; the idea that after the fall of 'Communism' between 1989 and 1991, no great historical issues were left to be worked through, that the operations of markets would take over and replace historical events.

And a box office – this destructiveness is not an end in itself; but a way of drawing new borders and boundaries so rent can be charged where it never was before, so "value can be added" in those margins and

backwaters where before there were only unprofitable things and cultures and private lives that might have been vibrant or abrasive or erotic, but were fiscally static.

In the name of restoration, rehabilitation, regeneration and liberalisation, cultural slates are wiped clean, damaged landmarks are razed, and displaced populations are displaced even further. Every effort is made to ignore and discourage memory, to erase or package the symbols of the past, to generate indifference, to dissolve roots and rhizomes in the name of global flow and flexible labour. This is the War on Memory.

Suddenly, the clumsy materiality of the heritage industry with all its THINGS – castles, city walls, big houses, ancient stones, crowns, suits of armour, union banners, Gatling Guns, picks and shovels, steam engines, stuffed animals and gilded frames – doesn't look quite so bad. In the face of psychological 'shock and awe' and the War on Memory, the resistance, recalcitrance and downright thinginess of those awkward and clumsy objects suddenly makes them rather more appealing.

In resisting the market in amnesia, counter-tourism will have to operate at a monumental scale, not in order to conserve a nostalgic past, but to create new, inconvenient memorials. Of course, we don't have resources of our own to achieve this, but the heritage industry does, and so... shock and awe! ... here begins a very short guide on 'open infiltration' in the heritage industry itself.

Of course, it's not beyond the bounds of possibility – I know because it has happened to me – that after making some interventions at heritage attractions, you will receive the call from within the heritage industry itself.

You may be invited to make some interventions with the official blessing of the local management or owners. Or you may be an artist or performer who makes – or has sought – work within the heritage industry. Or you may simply be extending your tactics and interventions to a scale where you will *have to* work on some level with the industry (or fight it head-on).

Whatever your circumstances, you have an opportunity for 'open infiltration', *a war on two fronts*. 'Open' because you don't have to make a secret of your counter-touristic tendencies. 'Infiltration' because you act *as if* you did. There is no need to be covert. If you've been invited it is probably *because* the heritage officers recognise and want a piece of that frisson your countering generates. If they're willing to talk to you at all then they're at least intrigued.

Operate on and within their terms – they're cherry-picking from counter-tourism. So give them cherries, communicate with them in cherries. You don't need to offer the whole orchard. If you try to sell them counter-tourism as a whole, then you will set up an open point of tension which they will have to face down, defuse or back away from – or possibly even worse: adopt and accommodate. There's no need to hide the ideas, but they're not all for sale.

This double approach (*open infiltration* and *war on two fronts*) doesn't have to be opportunistic; it's not just getting away with something. On the contrary, it is consistent with the most basic principles of counter-tourism: neither opposing nor subverting heritage-tourism, but feeding off its supply lines in order to create something different and to the side of it, pulling heritage from its edges, tipping it over gently.

Hence the two fronts: with managements and owners we can work on friendly terms on short-term projects; but with the dominant narratives of heritage we insert our fangs and keep sucking.

There are some useful general approaches, and here's one: be marginal and late in.

It may be tempting to have a say early-on in projects, or, as you win trust and create popular interventions, to accept more initiative and responsibility. Don't. If you're given more managerial initiative or made more central to the planning, then you will be negotiating from the start. You will never get the precision of intervention that you need. Get in late and stay marginal.

If you are at the centre, the only supplies you are living off are your own. If you're marginal, and use *asymmetrical* action effectively, you can commandeer all the force and energy of an iconic site or a project for your own diversion.

Asymmetrical action involves expending small amounts of your own energy in order, by very precise application, to commandeer and re-direct huge amounts of energy from other sources. The most notorious example is 9/11. In a heritage site, one

small sign, asymmetrically deployed, can change the meaning of an entire edifice:

You are standing on the face of a giant fault in the earth's surface! You are standing on a giant rip in time, hovering between...

Or transform the picturesque view from it:

Or dare you see through dead men's eyes? Like those of William Lee and Thomas Preston, swinging from a yardarm above the bay.

[Texts by the Crab Man on Rock Walk, Torquay.]

Get in late, when plans are fixed or things already built, so that you can place your intervention precisely, knowing exactly what static force there is for you to get your leverage off, to commandeer the energy of everything else. Get in too early and your intervention will get pulled out of shape by the changes and compromises that inevitably occur.

Again, there's no need to be mysterious about this tactic; but it's not what you're selling. Remember: the 'problems' of a site (monumental size, resistance to change, obstacles to flow) are the very things against which you can lever your asymmetrical effects. When all seems lost to others, *that's* the moment you can get the most done.

# Open Infiltrations

## Bad sign

In Weston-super-Mare I worked as part of the Wrights & Sites group of site-specific artists on a project for which we were asked to make an artwork to connect the various parts of a public art project, while expressing a logic of its own. We created a set of nostalgic-looking, apparently official plaques that addressed sites throughout the town in offbeat poetic ways, suggested actions and, as a whole, hinted that the entire town was ripe for re-making by its users – *Everything You Need To Build A Town Is Here*.

On the Rock Walk at Torquay, I was invited to write the text for a set of information plaques.

Although all these signs are fixed to walls or posts, the exploratory walking of the 'drift' is still an essential part of them. The Weston plaques encourage passers-by to make their own actions and explorations, the Rock Walk signs encourage visitors to repeatedly move between the vista and their texts.

Even when making new heritage objects, counter-tourists see these as springing-off-points for new actions.

## Potted

A reconstructed pot on display in a museum case in Worcester is labelled as being made up of 25% 'original' materials.

But what about the other 75%? The unoriginal, inauthentic, neutral?

Make displays using only the 'other 75%'.

In an ancient site concentrate on those parts that prop up, replace and add to the 'original' remnants – those things intended to be ignored – what happens when you focus *only* on them?

Remove the 'originals' and leave only the props and frames. Create a museum made entirely of supports, replacements and additions.

> **Make simple actions, gentle but precisely placed additions – let the sites fill what you do. Small provocations in the right place cause huge systems to shift and perform. What's important is not what you do, but what you cause other things to.**

## Palliative curation

Sacrifice a tenth of all heritage sites to unlimited public use. No limits at all. No codes of conduct. No repairs or renovation. No publicity for this; just remove the signs, ticket offices and policing. And you will see the biggest leap in historical consciousness since the ballad.

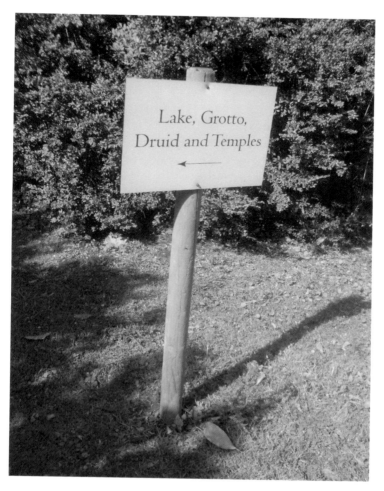

## Mannequin

In a museum I found an unnerving juxtaposition: immaculate, life-like, full-size models of Second World War soldiers next to stapled A4 sheets of text about, and fuzzy photos of, local soldiers killed recently in Afghanistan.

What if hyper-realist, life-like and full-size models were made of the soldiers killed recently in action, and displayed alongside fuzzy A4 photocopies about the Second World War?

## Etiquette

Just because a mainstream tourism organisation wants to co-operate with you – finding your ideas 'new' and 'different' – doesn't mean it is in their interests to do so. Tensions may arise and you may need to play your cards carefully – support and deliver for your allies within those organisations, without compromising them or leaving them open to attack from their less sympathetic colleagues. Be loyal to people rather than their organisations.

Work around those who identify themselves as your enemies, keeping them at arm's length, develop tactics for smothering their objections (mostly you do best to agree to any changes suggested and then finesse the changes to your own ends, using them as new obstacle-opportunities), avoid direct confrontations, and commandeer their official narrative as just 'one among many' in the orrery of your work.

Be open and honest about these tactics if you're using them; after all, the set of ideas that they spring from – mythogeography – is all about the interweaving of non-respectable and respectable narratives. Talk, if asked, about the principle of multiplicity that is at the heart of mythogeography; of expressing the many meanings of any site. But don't try to sell it. As a leaderless resistance there is no organisation for you to protect, only tactics to be dispersed; in *open infiltration* that's usually best done in small doses.

If you are told "you can't do this" or "you can't say that" – brilliant! They are telling you their secrets, showing you their boundaries, pointing out their powerful, hidden and forbidden spaces, and defining their silences. Use the power of these barriers obliquely, tap their tension without directly blurting them out.

## Sell out

Blue plaques for everyone.

## Furnace

I was told of a site where a large aristocratic property had burned down almost immediately on being purchased by a high profile heritage trust. Rather than preserve any ruins – the blackened walls, the isolated chimney stacks – the site was levelled and its gardens opened to the public. I recommended that the trace of the house be planted out in red, orange and yellow flowers.

## Oerol

In 2008, the theatre directors Robert Wilson and Boukje Schweigmann and designer Theun Mosk created a four hour symbolic walk on the Dutch island of Terschelling . The walk was 'performed' in slow motion by its audience, across the island landscape and in encounters with specially created corridors, walls and huts that closed down and opened up the vistas of the island.

Use (and realign where necessary) the existing features of a heritage site to create a route for a slow motion visit.

## National Missing Museum

Create a 'misplay' made up entirely of labels of apology for withdrawn, lost or stolen items.

## Morbiddable

Many cemeteries are tourist destinations. Famous people are buried in them. And one can hunt their headstones.

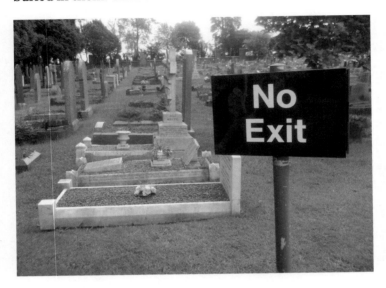

Even obscure cemeteries may contain a 'significant' corpse or two. (Don't have any illusions that "Death is a great leveller"; I once asked the famous spiritualist medium Doris Stokes if social inequalities melted away on 'the other side' and she assured me that "no, they do not".)

Cemeteries are architectural and social records in their own right.

In a St Petersburg graveyard I found the 1930s' tomb of an engineer on which the usual cross had been replaced by an electricity pylon.

In an Exeter graveyard I found this frank epitaph: "to an old faithful and invaluable servant... this stone is dedicated... by the family who enjoyed the fruits of her labour for forty four years". Hmmmm....

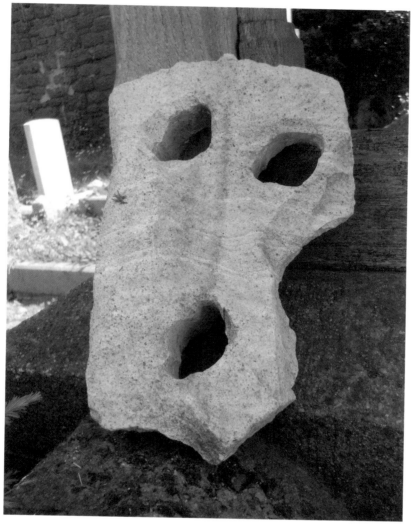

But what if Doris Stokes is wrong? What if retribution is waiting?

You could create the route for a day's walking between all the cemeteries in your city (or part of your city if it's a large one). Practising empathy, the route would encourage heritage tourists to visit the graves of those they do not know...

*"Woah! Hold on – this isn't counter-tourism in heritage sites, this is tourism in counter-heritage sites! This isn't the first time you've done that here!"*

OK, OK... by now it shouldn't come as any 'bombshell' to you to hear that there are no heritage sites: only ticket offices and fences. Yes, there are spaces that trusts and businesses say are heritage sites. And we've taken them at their word for the purposes of this *Handbook*. But, by any objective rule, everywhere is a heritage site, still aching and sore from the events of the day before, and resting on foundations made from bodies that died 400 million years ago in seas generated by four billion years of cosmic, stellar and finally planetary development.

Get your own back on state restrictions and private injustices by taking pleasure where it was not intended to be had. The heightened sense of place you develop in designated 'heritage sites', you can extend to your routine spaces – turning trips to the shop into theme park rides and archaeological digs. But not all the time – that kind of intensity, if permanent, will fry your mind – dip in and out.

Everywhere and everything is your heritage. Now, back to the grave...

...enjoy the same strange ironies in the cemetery as in any place of excessive feeling ("Thanks be to God for his unspeakable gift"), ponder the segregations (of 'dissenters' and dead babies), feel the dread of blank plaques and untouched expanses of grass, waiting, waiting, hungry for bodies, and the cold commerce of "this memorial is available for dedication" or the spaces marked "reserved".

On my daylong walk to all the cemeteries in the small city where I live, I was struck by the transience of individuality – that what seemed to erode first in the cemetery was that which was most eccentric. As if the sludgy homogenisation of heritage has something in common with death.

The cemeteries' backstages were piled with withered names and blanched novelties.

I imagined sneaking into celebrity cemeteries (Arlington, Montparnasse, Highgate), discretely smuggling in fake, artificially weathered gravestones engraved with the names of almost real people (Sherlock Holmes, Svengali, Jack the Ripper, Homer...)

Fake is fine; it's purity, authenticity and roots that we really have to fear.

## Gap tooth

Fill in the gaps in the heritage ruins with new buildings. The stripping down and sealing up of ruins in a frozen stillness is a recent fashion, only initiated in the last hundred and fifty years as tourist agencies and national and local authorities re-invented the past as clean, discrete, dead objects rather than vibrant and exotic things.

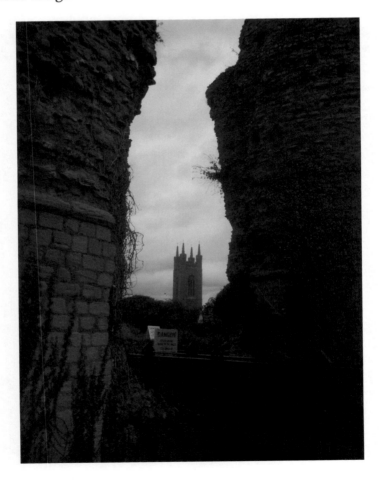

Rebuild the café, airfield and pig farm that stood alongside Stonehenge in the 1920s.

## An exhibition label

*"we must never lose our sense of proportion and start to worship the building, because however difficult it may be for the twentieth century to grasp, this building was always intended to point beyond itself"*

## Entrancing

Build absurd portals to heritage sites.

## Open a museum

*Le Globe de la Science et L'Innovation* at CERN, near Geneva, is an immense spherical exhibition centre. When it was first offered to CERN as an educational resource, one of the scientists there proposed that a miniscule ball be placed at its centre and the rest be left bare – to represent the tiny nucleus in the huge emptiness of the atom; to exhibit the nothingness that predominates in space. The management naturally behaved abhorrently towards this vacuum.

But you could use the same principle to open subtle museums; of pauses, intervals, wind, decompositions, atmospheres. Travel to Rosslyn and bring back for your museum the 34 metres of the chapel that were planned but never built. Curate lines of empty bottles on windowsills...

## Pop

Install inflatable castles, inflatable forges, inflatable mills, inflatable country houses, inflatable museums, inflatable palaces, inflatable cottages, inflatable follies, inflatable parliaments, inflatable earthworks...

## Holey global empire

Map all the secret tunnels (proven or not, map every tale of passages) and connect them up.

## Corridors

Re-introduce the wild. In marked containers: wild channels, mile wide corridors in which there will be no building, no agriculture, no dogs, no history... do the same in the seas...

## Economy

Remove all but essential signage ('sheer drop', 'alligators running free') from a site. Remove all fences and boundary walls (except those necessary for animal husbandry).

Remove all place names, create a space for the return of memory (Plato was right, writing has made us stupid. Chatting can make us clever.)

## Never

Go to a river. Take with you some frames, a glass case, a ticket office, a large building, an interactive display, a butterfly net, a scalpel, an app, an invigilator...

Extract two samples from the river and attempt to display them as identical.

I went for a 'drift' in the suburbs and found many survivals. Near a road called Green Lane I found a sunken, grassy 'hollow way' running behind back garden fences, I found extravagant splatters like giant squid where someone had dropped a tin of paint, and there was an eighteenth-century mansion with a dramatic Doric portico nestled among the 1980s' bungalows. I asked a resident of one of the bungalows about the mansion and he described its shift from private to public ownership and recent reversion to private residence; together we lamented this loss of public space, but the

man chose to turn this into a general moan, a world view of pernicious 'deterioration'... I thanked him and wandered away; for me, such deteriorations are revealing erosions rather than moral declines, and this loss of public space is but one defeat that generates tensions I can savour.

Counter-tourism accentuates the positive; confronting the everyday with its own wonder. Everywhere and everything is its heritage. Draw no lines.

## Now

I visited Moscow in 1990 a few months after the coup against Gorbechev and was taken to a museum where they had gathered an entire street barricade and reassembled it in one of the rooms.

Encourage museums to intervene at moments of significance and lift whole scenes and place them in their own dedicated room.

## Smooth

Waxworks and fashion
museums should all go
naked on one day each year.

## Conservatively
## speaking

There are different ways of
preserving historic spaces.

On one day Eleanor,
Christine and I visited two
very different places.

Ending up in the grounds
of a grand country house,
we passed a party having a full-blown picnic (with hamper) in the
car park, and then ourselves became becalmed in a commercial
area of plant shops, second hand bookshop and café. We never
did bother to go through to the house. Eleanor had visited this
mansion on many occasions, but was unable to recall a single
piece of historical information about it; despite its 'authentic'
preservation, guides and information boards.

Earlier that day we had visited, in the guise of parents intent
on booking birthday party treats, a Paintball Zone located in
a former 'semi-nuclear bomb proof' communications bunker,
and were generously shown its corridors and former operations
room. (Some Khlestakovian Inscrutability was deployed.)
Eleanor flashed back on the horror movie *Hostel*. I'd 'visited' here
after it had been abandoned by the RAF in the early 1990s and
was surprised at how recognisable it all still was.

The young employee showing us around was very keen to tell
us it was haunted – just like a 'real' heritage site – things moved
around on their own.

> "kill is kiss" – history is what you believe it to be... stone is an idea that you have about not changing... if you live by the vibrancy of things, see what happens. Can you find the sudden explosion, the beginning of the unravelling, the split second transcendence, the transfiguration of body and place together, the exchange of one thing with another?

Somehow the sight of all the laser guns stacked up waiting for the young combatants that morning – "the sense of desolation and despair... and without even trying to do that", said Eleanor – had conserved more of that site's meaning than the conscientious restoration of a country house by a national charity.

In the ideal society imagined in his utopian novel *News From Nowhere*, William Morris, a founder of the Society for the Protection of Ancient Buildings, depicted London's Houses of Parliament conserved as a "storage place for manure".

Take a derelict site and turn it back into itself by making it something else.

## Touchy

Create souvenir objects based on the atmospheres and abstract shapes of a site. Make one set of large-scale 'originals' of these and place them in a key spot, big them up, give them aura, display them as if they were the 'crown jewels' of the site; in the entrance hall or the Visitor Centre. Then have miniatures of the 'originals' available for borrowing, purchase or gifting (use the reception desk, café or gift shop for this); with a map of suggestions for where on the site to fondle particular shapes.

## Nomadic Giants

Huge objects go walkabout. A few years ago I found parts of the Reichsbrücke, Vienna's famous bridge that collapsed in 1976, on the Kagran rubbish dump outside the city, a herd of endangered mountain goats perched on its white blocks.

Four of fourteen covered domes from Old London Bridge can be found dotted about the English capital. Temple Bar Gate has moved from Temple Bar to Paternoster Square, via a clearing in the woods on a Hertfordshire estate.

Choose an iconic heritage building. Divide it into a thousand pieces and relocate them to 'everyday' spaces; the Eiffel Tower could be everywhere...

## Lily of Lacunae

KING EDWARD STREET has become KING WAR STREET.

When the powers-that-be on the Dartington Estate in Devon removed the arts college from their grounds, students and their supporters removed ART from local signage:  D  INGTON.

Edit the world.

## More than you can see

In the ruined gatehouse of the town of Domme in the Dordogne Valley, members of the Knights Templar – the elite religious order of mediaeval Europe – were imprisoned for long months during 1307. Their entire order had been banned by Pope Clement V and their suppression was led by Philip IV of France. Many of the Templar Knights were soon to be executed.

Awaiting their fate, the prisoners at Domme covered the walls of the gatehouse with graffiti. Some was satirical; portraying Clement as a demon. Much of it was coded and geo-mystical.

> *square = the Temple at Jerusalem*
> *circle = their imprisonment*
> *octagon = the Grail*

Unfortunately, such codes can be made to work backwards. Real sites can become geometrical concepts in the minds of people who have the power to change things in the real world. The Palestinian author and walker Raja Shehadeh has written of how places in his homeland became abstract concepts in some minds, to the cost of those who actually lived and live there: "The accounts I have read do not describe a land familiar to me but rather a land of these travellers' imaginations... what mattered was not the land and its inhabitants as they actually were but the confirmation of the viewer's or reader's religious or political beliefs... Perhaps the curse of Palestine is its centrality to the West's historical and biblical imagination..."

Heritage managers might be a little less keen on dissolving their sites into experiences and brands if they considered for a moment how such processes might be reversed.

Greece and Egypt have suffered the same dematerialisation as the 'Holy Land' at times: concept-places, without significant people. Less so since Tahrir Square and the anti-austerity riots.

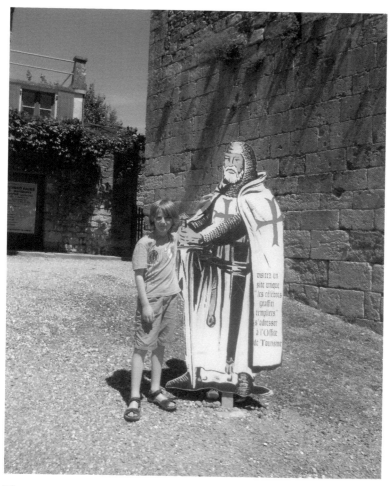

If you ever visit Domme, ask the guide to show you the X-ray photography of the graffiti. It reveals that around the cryptic shapes and religious drawings, in every square inch of empty space, the Templars lightly scratched the images of thousands and thousands of faces, one squeezed against another, as if the knights lived imprisoned in a cloud of eyes and noses and mouths.

People. Not in every space, but in every place – people!

# Afterword: The heritage IS the visit

## Where does counter-tourism come from and where is it going?

I am going to get personal and theoretical here. As tourists of any description, we are in a war of meaning and memory and we need to get the strategy right. Since counter-tourism asks you to head off into the contested territory of heritage it's important to know that it provides you with the right maps. There's also something of a pilgrimage about all this; although it has no destination. Modern day tourism has retained a little of the old pilgrim journey – with sunblock rather than anointing oils and self- transformation rather than adoration as its *modus vivendi*. It's only fair, then, that I should let you in on the bigger journey of which counter-tourism is just a few recent steps – one that I hope you will now take off on your own tangents.

In 2009 I joined this fractious pilgrimage when I began three years of research. For ten years before that I'd been performing 'mis-guided tours' (see 'The Mis-Guided Tour' above). These tours were inspired by ideas I've come to call 'mythogeography' (ideas that put the highest value on journeying, hyper-sensitisation to the everyday and keeping alive the many meanings of places in the face of those who would homogenise them). I'd made 'mis-guided tours' in the backstreets of Naples and Zurich, in English mining villages, urban wastelands, 'historic landscapes' and in National Trust properties in the UK. Now I had a chance to spend three years testing them – did they really change people's understanding and use of places? Could I adapt them to make them better? Could I spread their principles to other kinds of intervention?

I chose to limit myself to heritage sites. I had an intuition that these had a powerful resonance for their visitors, serving as fanciful, nostalgic and utopian spaces. I gathered together a 60-strong panel of volunteers who came along, tested out and

commented on my interventions – their responses suggested that my interventions were generally doing what they set out to do. But they also pointed up a mis-match. I'd assumed that the audience for my research findings would be other specialists: performers, lecturers, heritage professionals. My panel members, however, came from a wide range of working backgrounds and they all seemed quite capable of grasping the ideas and the tactics, telling me when I got them wrong and going off and using them for their own purposes. Could I spread the tactics to *all* visitors – to the public in general?

'Counter-tourism' is the attempt to do exactly that. How I got there goes something like this:

### The agentive tourist in a chorastic space

Heritage tourism is driven by national, local, communal and cultural identities. But, in fact, it also partly produces them: it is also a setting where people make themselves – a remnant of the old pilgrims' 'progress' in which travellers define themselves against what they find as they travel. This can be broad brush (goths in an imaginary nineteenth-century Whitby, patriots before statues of Abraham Lincoln or Peter the Great) or very subtle, just a feel for a period or a thrill at an old detail. In tension with this, 'mythogeography' is very resistant to any sense of fixed or singular identity – even to any sense of identity at all. At most, it encourages people to welcome the strange or unfamiliar and to embrace a multiplicity of identities. So this story begins with a friction.

'Mis-guided tours' use this friction for fuel. The 'mis-guides' who lead the tours adopt hybrid personae, parodying impersonations of historical figures, stealing from the patter of mainstream tour-guides, but then allowing each 'voice' to break

down or become swamped by others. This matches what a German critic, Hans-Thies Lehmann, has called a 'post-dramatic theatre', characterised by 'disintegration, dismantling and deconstruction... experienced... as not a story read from... beginning to end, but a thing held full in-view the whole time... a landscape'.

All of this sits very comfortably with my interventions as a 'mis-guide', but *not* with my attempts to pass on such tactics. One specialist talking to another is hardly 'dismantling and deconstruction'. And when I've tried to come up with models for dispersing ideas, they've been things like 'cells', borrowed from political activism, and have been, rightly, ignored. So I went back to an idea from Tourism Studies: 'the agentive tourist'.

The idea is this: tourists don't just consume tourism, they produce it. In the '60s and '70s they were generally portrayed as the duped victims of a massive manipulative industry. But once academics studied what tourists actually do, they realised that they construct all sorts of variations and re-assemblages from the attractions offered by the massive manipulative tourism industry. Tourists subject the sites they visit, heritage or otherwise, to their own associations, stories and reconstructions. They are, in fact, not passive, but agentive.

Now, in one way this is enormously encouraging – the making of a multiplicity of viewpoints and meanings is, apparently, regularly observed among ordinary tourists, if not always in a deeply self-reflective manner. But this didn't seem enough on its own to describe the ways that tourists construct their tourism. I'd seen people making their own enjoyment and understanding, but it wasn't a

making that was always free, reflective, inevitable or un-manipulated.

So, now there were two major problems – I had no way to spread ideas and communicate tactics and no real understanding of where the magic or motor for tourists to make their own tourism came from (it wasn't enough just to say that they did). I sensed the two things were connected – and making each other worse. It was then that circumstances rode to my rescue.

I'd not long before co-produced and privately circulated a mini-handbook on making 'mis-guided tours' - *A Sardine Street Box of Tricks*. It describes how a tour was made and gives the basic techniques. Simple. It didn't involve 'cells' and the approach was suggestive and indicative rather than didactic. In six months this little pamphlet with barely any distribution was used on 28 projects, from movies to solo explorations. At last, there existed a vehicle: a simple handbook. Not to help specialists lead others, but for those 'others' to lead themselves; something that added to the agency of agentive tourists, while offering them the self-awareness of 'mis-guides'. Visitor groups of friends and families provided the 'cells'. The potential site of mythogeographical intervention suddenly

expanded, from places where a mis-guided tour would be tolerated to just about any heritage space at all.

This was complemented by what seemed at the time like unconnected reflections on a mis-guided tour called Water Walk. Something distinctive happened on that tour – my panel members' responses showed that it not only triggered the usual altered perceptions, but had caused people to reflect, and act, on the way in which they were constructing meanings while in the act of producing them. Water Walk was a quieter tour than usual, with less commentary and more focus on simple almost ritual-like actions at different 'stations' along the route, each relating to some aspect of water in the history of the site (around the Quayside in Exeter). This was all set up with an opening 'lecture' in which, consistent with post-dramatic dismantling, the 'mis-guides' (Simon Persighetti and myself) announced in detail, in a kind of exorcism, all the guide-like actions we would not be performing and all the guide-like information we would not be sharing. We took off our blazers and left behind our pointing sticks, but resurrected our guiding roles in spectral form; leading the way and organising the participatory actions.

So, what connected these means and the audience's self-aware and self-reflective re-making of a site's significances? This question chimed with an idea proposed by geographer Stephen Wearing (and others) that tourism sites have a common, if often latent, quality he called 'chora'. This 'chora' is a notional space somewhere between how things are and how they might be, a space that can, temporarily, resist any obligations of exchange

or commerce, where identities and hierarchies can be evaded for a while, a potential space of transformation, a transitory space that a particular kind of performance might be able to bring into being and sustain for a while. Something in Water Walk had taken audience members to this space, where they began to consciously reconstruct heritage; – so! – it wasn't just a case of arming the agency of tourists, but providing the right map to the 'chorastic' landscape.

'Chora' matched my hunch about the resonance of heritage sites, while realistically taking account of the strength of the codes at work in tourism. For 'chora' was a kind of pre-ideological space where the codes were not quite up to speed, and, briefly, could be subjected to the poetics of subjectivity, shifted by individual will and imagination. The double movement of the Water Walk – first exorcism, then spectral resurrection – seemed to invoke this 'chorastic' space; it seemed to permit the remaking of heritage as a heterotopia (a utopia without walls, an explosion of ideals rather than conformity to one).

So, here – unexpectedly – was the underlying strategy of counter-tourism: the familiar forms of heritage tourism exorcised and then spectrally re-enacted by its own visitors to trigger access to the 'chorastic' qualities of transformative potential in heritage sites. That's why the tactics in this *Handbook* and sister *Pocketbook* first parody and then resurrect the etiquette of the heritage visit. A double movement to open 'chorastic' space to you and to open you to your own 'chorastic' potential; transformation triggered by pleasure and a pilgrimage ending who knows where. So counter-touristic visits are not to things; the 'thing' of the visit is the visit itself. Starting with simple playfulness, counter-tourism provides a toolkit for all tourists; the most adventurous will find

tactics for making post-dramatic interventions, even infiltrating the heritage industry, but even for the most far-reaching of these personal journeys the primary tactic will remain a simple exploration on foot – the underpinning tactic shared by all.

But an exploration of what?

In the 'fever of the present', when 'our entire contemporary social system has little by little begun to lose its capacity to retain its own past' is there anything there to explore? If 'the separation between past and present has been eroded', if 'heritage conservation is creation and not preservation of what already exists' and is 'gradually effacing History, by substituting an image of the past for its reality' what actually *is that stuff* in heritage sites? The formula by which I've arrived at some kind of an answer - that through rigorous empirical study it is still possible to construct *locally* meaningful historical narratives, but that they break down at a certain spatiotemporal or conceptual scale - comes not from any theory of historiography, but from a 'mis-guided tour'. Standing next to a wall on the Quayside at Exeter I realised that from a single piece of sandstone breccia I could give a coherent narrative of desert formation and flooding 300 million years before that was specific to that stone, but that the story became meaningless if I used the formulation 'here 300 million years ago'. There *were* deserts, there *were* floods and there was a past, but to connect 'here' to those things 'then' was impossible. 'Then' the materials that now make up 'here' were on the other side of the equator and in a formation completely unrecognisable from anything here and now; indeed 'here and now' is simply their momentary meeting point along billions of different trajectories before they head off again in novel combinations on unrehearsed

journeys. And that piece of wall was no different from ink on a Declaration of Independence or mobile phone footage of the killing of Gaddafi: materially and empirically sound, but liable to disintegrate into multiplicitous trajectories if forced into too generalised a narrative such as 'the rise of freedom' or 'the spread of democracy'.

Now, this isn't a wholly pessimistic viewpoint; it still leaves a space for those enquirers who intuit the gaps, margins, the boundings between the meaningful and the wishful, silences, silencings and guises in heritage narratives. Having identified them, however, my suggestion is that we should avoid making corrections or seemlessly filling in the gaps. That only hides the heritage industry's gradual replacement of the past with other things; for example the comfort of spaces where visitors may 'encounter... people socially like themselves' and 'distinguish themselves from others'. Laurajane Smith's English stately home research demonstrates that what drives such visitors' sense of the authentic and their identification with such places is not the historical narrative of the houses, but rather it is *the visit itself* that visitors see as authentic, and their emotions in them as what are most 'real'. Rather than denouncing this as a crass obliteration of history, counter-tourism recruits the idea that

it's *the visit* that's the real historical object of these sites, pushing it to excess, so counter-tourists over-perform visitors'

experiences of image-bathing and immersion, even the most conventional tourist's wish for 'peace and quiet' is pushed to extremes and transformed (see 'Castles in the Air' above) turning a site into dreams, while exposing where these personal indulgences assume the condition of structures such as subservience, imagined-integration and identity formation. By performing to excess, the counter-tourist can trip up and suspend these processes, so that 're-living the past' becomes the making of a new thing from the most abject of mistakes, excesses, out-speakings, anachronisms and silencings. Even from the simulacra of the 'ploughman's lunch' in the cafe and the 'children's crusader costumes' in the gift shop. Not in order to show 'the reality behind the illusion' but to expose 'the reality in illusion itself'.

For where else than in illusion would we find reality, when there is no history?

## The past on a life-support machine

I don't mean that there was no Battle of Waterloo, Iraq War or Japanese Tsunami. But I do mean that there is no such thing as that coherent, accessible and objective narrative of the past which seems widely imagined to underpin the stories told in heritage sites. And I do mean that the intensity of that absence is historically specific to now rather than a universal problem. O, this is difficult ground and easily misunderstood as relativistic despair. But we're not talking Baudrillard's 'desert of the real' via *The Matrix* here. Nor indeed any philosophical argument at all. For I'm going to argue this on the basis of personal feelings and you'll have to trust me or, better, trust your own intuitions and make a judgement.

After working in heritage sites for some years I have come to *feel* that I have always been among ruins there. Not in the sense of material remnants like the stones of derelict Dissolution monasteries, but rather that no matter how well

signed, interpreted or managed, or how recently constructed or conserved they may be, all heritage sites are places of waste, decay, remains, excretion, horror and disgrace, bodies from which life is gone (but whose death is hidden) and which are kept 'unnaturally' propped up, their parts kept moving on a life-support machine long after their life has departed.

This feeling of abjection has been regularly re-fuelled by experiences such as discovering a beautiful obelisk plaque tucked, in three broken, forgotten pieces, under a heritage property gardener's workbench, being warned off mentioning the mass grave on a picturesque property, or discovering that a courtesy visit to a quiet English canal by midget submarines was a rehearsal for planting nuclear bombs in Russian ports. And all the while the heritage corpse is re-animated in a dance of death called 'living history': 'living heritage is an oxymoron... The reason that living must be specified is because the very term "heritage" signifies death'.

This afterlife of heritage objects is far from unique to its industry. Rather, it is the paradigm of our times. It's no accident that the zombie is THE monster of the early twentieth century. For, if god is long dead – victim to materialism, it's now materialism's turn to suffer: in the face of information technology and the dematerialisation of everything into the virtual – and now it's history that is looking distinctly peaky.

'The globalisation of the false' has become 'the falsification of the globe'. Which is not to say that there is no longer a 'real', but rather that there is no real that can serve as an authoritative alternative to contemporary narratives of fake and falseness. Given the velocity of information exchange, there is no longer a 'reality at rest' as a frame from which accuracy or enquiry can launch itself properly or find real leverage (this is the conceptual equivalent of my difficulty with 'here 300 million years ago').

All this is helped along by a tendency in the contemporary

political economy sometimes called 'catastrophe capitalism' which seizes on natural and man-made disasters to wipe clean all space and memory – with a coruscating effect on history and heritage – to make room for new markets (remember the 'indifference' of the invading armies to the looting of Baghdad's museums, or the less well publicised second devastation of Asian coastal communities – first tsunami, then 're-building' inland, devoid of the things of the past?). But don't despair, the apocalypse is also here to help us, 'distinct from crisis and catastrophe... an end with revelation, a "lifting of the veil"... not the [end of the] sum of all things but the [end of the] ordering of those things in a particular historical shape... this doesn't mean total destruction but rather a destruction of totalizing structures' and what is revealed by this is not 'who's behind this mess. It's the fact, persistence and resistance to thought of the mess itself... all that we know very well yet regard as exceptional nightmares or accidents'. We may be losing ancient vases, but the forces and social relations that have preserved, fetishised, restricted, defined, valued and sucked all meaning from them are appearing more nakedly than ever before (and what normal practices they turn out to be).

So enjoy an 'apocalypse now' in the heart of heritage, because it's telling us something. Not that the end is nigh. But that if we act 'as if' one is happening then in its comic ruins (among interactive features that never seem to work or piles of costumes Jakarta teenagers dress up in as their great grandparents' colonial rulers) we can tangle with the narratives of 'catastrophe capitalism' as they sweep, not quite in command of their own destiny, through heritage sites wiping their slates clean, each wave a new front in the 'War on Memory'. And we *can* fight it; making an apocalyptic revelation from the fragments of the past, redeploying the smears and broken bits of repeated wipings. And laugh ourselves silly (when self-destruction is the consequence of being 'sensible') in the permanent present of a procession of novelties: ghost tours, re-enactments, costumed guides, treasure hunts,

simulations, interactivities, 'responsibly sourced' cafés, site-brandings, 4D cinemas, 'Jurassic Theatres' and so on. For these are not marginal irritations behind which lies the authentic revenant; these obfuscations have reached such a point of accumulation that, rather than framing or obscuring the past, they are now replacing it with themselves.

This is the particular sense in which 'there is no history' in the heritage industry and it is that 'no history' that we can overproduce, take to excess.

Counter-tourists can respond to the New Fakeness not by trying to restore lost authenticity – though we do, perversely, love those moments when a slick new refurbishment trips over a recalcitrant slab in the ground – but by taking literally the miserablist assertion that tourism is 'a device for the systematic destruction of everything that is beautiful in the world' and finishing the job. The heritage industry invites its customers 'to step back into the past, to relive it'. Counter-tourists accept this absurd invitation to step into a grave in the knowledge that 'the form of this reliving is consumption', which, when passed through the prism of 'the agentive tourist', makes the tourists (counter or otherwise) as much the makers of 'the past' as Saladin, Sylvia Pankhurst, the Iranian working class and Typhoid Mary, or Madame Tussaud, Mongolian shamans, Simon Schama and Mary Beard. It is in this farcical 'as if apocalypse now' of heritage – 'nigh' as never before – this absurd democratising of once hierarchical spaces in which every visit is a starting from scratch (to borrow a tactic from 'catastrophe capitalism') – that every visitor can begin to imagine how heritage spaces might re-emerge from the complete ruin not of their objects and artefacts (a deadly combination of military machines and conservators can be trusted with that), but of the *totalising structures* of their stories: these – the abject, oozing machine parts of an industry that could churn out 'national identity' and 'peace and quiet' – are the ruins of history on which the multiplicitous future can be built.

# Notes and Further Reading

If you are interested in making your own mis-guided tours, then Signpost (Simon Persighetti) and I have written a handbook for anyone wanting to make a tour: *A Sardine Street Box of Tricks*. (Axminster: Triarchy Press, 2012). www.bit.ly/crab223

If you want to follow up on the uses of walking, particularly the use of the 'drift' or 'dérive', you'll find plenty in *Walking, Writing and Performance* (Bristol: Intellect, 2009), *A Mis-Guide To Anywhere* (Exeter: Wrights & Sites, 2006), and for the deep background try Francesco Careri's *Walkscapes* (Barcelona: Editorial Gustavo Gili, 2001).

Unsurprisingly, *Mythogeography* (Axminster: Triarchy Press, 2010) is the place to go for more background on the 'mythogeography' that informs counter-tourism. www.bit.ly/crab224

**Crude**: the 'id' is the unorganised and chaotic part of a personality, the terrain of basic drives, where contradictory impulses operate side by side without ruling each other out; amoral, unconscious and inaccessible. (p.17)

The idea in **Home** of the different meanings of the same space for those with greater or lesser power is drawn from Doreen Massey's concept of 'power geometry' in *Space, Place and Gender* (Minneapolis: University of Minnesota Press, 1994). (p.25)

Christine Johnstone's comments (**Relatively speaking**) can be found in 'Your granny had one of those!' How visitors use museum collections' in *History and Heritage: Consuming the Past in Contemporary Culture* John Arnold, Kate Davies & Simon Ditchfield (eds.), Shaftesbury: Donhead, 1998. (p.28)

For information on Harry Bensley: www.bit.ly/crab225 (p.37)

Information on Alyson Hallett's journeys with large stones mentioned in **Shifting heritage** can be found on her website at www.thestonelibrary. com and in her poetry collection *The Stone Library* (Calstock: Peterloo Poets, 2007). (p.38)

For more **Sex Tourism**, retrace the route of Stewart Home's ' A report on psychogeographical sex in Scotland' in *Confusion Incorporated* (Hove: Codex, 1999). (p.40)

For a comprehensive and incisive analysis of Bungay's Black Dog, and upon which I have drawn heavily, read *Shock! The Black Dog Of Bungay: A Case Study In Local Folklore* by David Waldron and Christopher Reeve (Harpenden: Hidden Publishing, 2010). (p.47)

The idea of causes and effects reversed is borrowed from Slavoj Žižek,

*They Know Not What They Do* (London: Verso, 1991). (p.48)

The story of Hy-Brazil is taken mostly from Donald S. Johnson's *Phantom Islands of the Atlantic: The Legends of Seven Lands That Never Were* (New York: Avon Books, 1998). (p.55)

**Abject**: like works of art, the ruins and remnants of heritage are a kind of waste, an end product, the remains of so much living and doing. Just as looking on the dead body of a loved one is a shocking experience, so

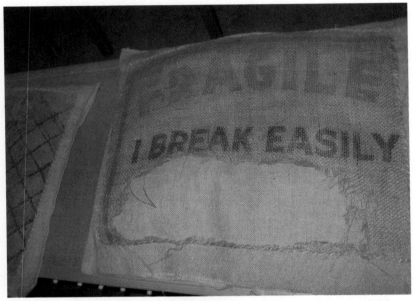

with the remains of the past; it *is* them and yet the life that they were is no longer there, they are a travesty of themselves. Bodies, though, like ruins, are not empty husks – they ooze and run; they may be dead and gone, but they are not lifeless. Thanks to the cosmetic efforts of the industry, a heritage site might on the surface seem fixed, orderly and parched, but peel back that skin and you find a warm, damp, hidden space, teaming with new life – bustling with the maggots and flies of the future. That's the abjection of heritage. (If you ever hear the phrase "living history", run for your life... the dead walk the earth!) For more on the abject, Julia Kristeva elaborates at length in her *Powers Of Horror: An Essay in Abjection* (New York: Columbia University Press, 1982). (p.59)

**Triffids**: information on the extermination on Lundy (and much more, including a future-oriented approach to the past) can be found in *Anticipatory History*, Caitlin DeSilvey, Simon Naylor & Colin Sackett (eds.) (Axminster: Uniformbooks, 2011). The argument for 'alien invaders' has

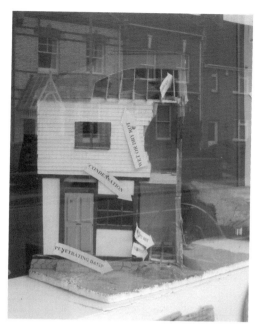

been drawn partly from
G. M. A Barker's paper
'Which Wildlife? What
People?' (undated) which
is available online at: www.
bit.ly/crab226 (retrieved
14.2.12). (pp.60-2)

**A Borges map** refers to
the story of the map of an
empire that is the same
size as the empire, from
*On Exactitude In Science*,
a short fiction by Jorge
Luis Borges, collected in *A
Universal History of Infamy*
(trans. N. T. Giovanni),
(London: Penguin Books,
1975). (p.64)

Two newsletters published
by the Equi-Phallic
Alliance, referenced in
Doctor Mintern, can be
downloaded at: www.bit.ly/crab227 (retrieved 12.2.12). The Underchalk:
it is believed by some that the English Countryside is a conspiracy, a
vast illusion draped across parts of the land (particularly in the southern
counties) and hung on props and poles. That landscape art and poetry
are parts of this conspiracy, which in turn is itself part of a wider romantic-
nationalist conspiracy of Englishness confined to the rural. Part of this
belief is that an intrepid explorer can tear through this spectacle to reach a
hidden and older landscape: the Underchalk. (p.68)

**Ironic-Platonic**: 'dread'
refers to a feeling of
anxiety the source of
which cannot be identified.
(p.73)

**Weather**: the quotation
from Alan Brownjohn's
poem 'Snow In Bromley'
is taken from *Collected
Poems, 1952-1983*
(London: Secker &
Warburg, 1983). (p.80)

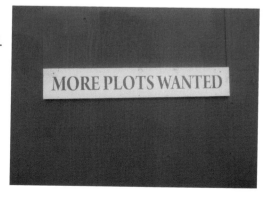

I first read of some of the unbuilt structures mentioned in **Potential** in *London As It Might Have Been*, Felix Barker and Ralph Hyde (London: John Murray, 1982). (p.82)

The concept of 'psychodemiurgics' is drawn from a pamphlet by Gilbert Nelson, *Psychodemiurgics* (Corby: Domra Publications, undated). (p.97)

Chthulhu: a monstrous aeons-old inhuman intelligence asleep in an underwater city, an indescribable edifice of patient tentacles, an alien character from the dramatis personae of H. P. Lovecraft. (p.120)

The information on illegal carding sites was drawn from Misha Glenny's *DarkMarket: CyberThieves, CyberCops and You* (London: The Bodley Head, 2011). (p.121)

There is a full account of *salvagepunk* in Evan Calder Williams's *Combined And Uneven Apocalypse* (Ropley: Zero Books, 2010). (p.125)

The quotation in the **Z worlds** section is from *Mythogeography* (Axminster: Triarchy Press, 2010, p. 204). (p.129)

A fuller account of the story of A la Ronde in **Life in the round** can be found in Phil Smith's paper 'A la Ronde: eccentricity, interpretation and the end of the world' in *Performing Heritage: Research, Practice and Innovation In Museum Theatre and Live Interpretation*, Anthony Jackson & Jenny Kidd (eds.), (Manchester: University of Manchester Press, 2011, pages 158-171). (p.132)

**Eroto-Phys**: information about Christian Nold's emotional mapping is available at www.biomapping.net. (p.168)

**Art of Living**: the idea of *an art of living* is inspired by the utopian resistance of the International Lettristes; there is an insightful account of their project in McKenzie Wark's *The Beach Beneath The Street: The Everyday Life and Glorious Times of the Situationist International* (London & New York: Verso, 2011). (p.168)

The idea of a site that migrates in **Authenti City FC** is drawn from a description of a mobile jungle city in *Internationale Situationiste*, No. 3, December 1959, page 13, cited in *On The Passage of A Few People Through a Rather Brief Moment in Time: The Situationist International 1957-1972* Peter Wollen, Greil Marcus, Tom Levin, Mark Francis, Elisabeth Sussman, Mirella Bandini & Troels Anderson (Cambridge, MA: The MIT Press, 1989, p. 144). (p.173)

**Misinformation centres**: there is an account of 18 Folgate Street by its creator in Denis Severs's *18 Folgate Street: The Tale Of A House In Spitalfields* (London: Chatto & Windus, 2001) and of the Museum of Jurassic Technology in Lawrence Weschler's *Mr. Wilson's Cabinet of Wonder: Pronged Ants, Horned Humans, Mice on Toast, and Other*

*Marvels of Jurassic Technology* (New York: Vintage Books, 1996). (p.176)

My account of 'catastrophe capitalism' draws upon Naomi Klein's analysis in her *Shock Doctrine: The Rise of Disaster Capitalism* (London: Penguin, 2008). (p.178-9)

**Bad sign**: documentation of Wrights & Sites's signage is here: www.bit.ly/crab228 (retrieved 14.2.12). (p.184)

**Etiquette**: an orrery is a mechanical device for demonstrating the motion of planets and satellites in the Solar System. For mythogeographical purposes, the orrery is an imaginary one from which the sun has been removed; a mental 'device' to demonstrate the movement of ideas and things around each other without a single, central, organising mass. (p.188)

**"kill is kiss"** is a quotation from the movie *Pontypool* (2008, dir. Bruce McDonald) in which a virus is passed on and then, later, neutralised through language. (p.200)

**Touchy**: these objects are based on ones ('things-meanings') created with designer Polly Macpherson for *Ambulation*, an exhibition at Plymouth Arts Centre (UK) in 2010. (p.200)

The quotation from Raja Shehadeh in **More than you can see** is taken from his *Palestinian Walks: Notes on a Vanishing Landscape* (London: Profile Books, 2008). (p.202)

In the **Afterword: the heritage IS the visit**, ideas about post-dramatic theatre are drawn from Hans-Thies Lehmann's *Postdramatic Theatre*, trans. Karen Jürs-Munby (London: Routledge, 2006). The particular idea of 'chora' here is proposed by Stephen Wearing, Deborah Stevenson and Tamara Young in *Tourist Cultures: Identity, Place and Traveller* (London: Sage Publications, 2009) and draws on a characterisation of the term by Elizabeth Grosz in "Women, *Chora*, Dwelling" in *Postmodern Cities & Spaces*, eds. Sophie Watson & Katherine Gibson (Oxford: Blackwell, 1995). Laurajane Smith's research on country house visits can be found in "Deference and Humility: The Social Values of the Country House" in *Valuing Historic Environments*, eds. Lisanne Gibson & John Pendlebury (Farnham: Ashgate, 2009). The origins and operations of 'catastrophe capitalism' are described by Naomi Klein in *The Shock Doctrine: The Rise of Disaster Capitalism* (London: Penguin Books, 2008). The quotations on a revealing apocalypse are from Evan Calder Williams's *Combined and Uneven Apocalypse* (Winchester & Washington: Zero Books, 2011).

# Filmography (movies cited):

*Aliens* (1986, dir. James Cameron)
*The Awakening* (2011, dir. Nick Murphy)

*Dawn of the Dead* (1978, dir. George Romero)
*The Devil's Footprints* (2010, dir. Siobhan McKeown)
*Die Hard* (1988, dir. John McTiernan)
*Downfall* (2004, dir. Oliver Hirschbiegel)
*GeoQuest* (2010, dir. Siobhan McKeown)
*The Man Who Fell To Earth* (1976, dir. Nicolas Roeg)
*October* (1928, dir. Sergei M. Eisenstein)
*Psycho* (1960, dir. Alfred Hitchcock)
*Quatermass II* (1957, dir. Val Guest)
*The Spanish Prisoner* (1997, dir. David Mamet)
*Stalker* (1979, dir. Andrei Tarkovsky)
*V for Vendetta* (2005, dir. James McTeigue)
*Wish You Were Here?* (2011, dir. Siobhan McKeown)

## Recommended viewing

*C.S.A. The Confederated States of America* (2004, dir. Kevin Wilmot)
*The Fog of War* (2003, dir. Errol Morris)
*Ghostwatch* (TV, 1992, dir. Lesley Manning)
*Ludwig: Requiem For A Young King* (1972), *Karl May* (1974) & *Hitler: A Film from Germany* (1977) (dir. Hans-Jürgen Syberberg)
*I Was Monty's Double* (1958, dir. John Guillermin)
*It Happened Here* (1965, dir. Kevin Brownlow & Kevin Mollo)
*It's Nice Up North* (2006, dir. John Shuttleworth [Graham Fellows])
*London* (1994), *Robinson In Space* (1997), *Robinson In Ruins* (2010) (dir. Patrick Keiller)
*Lourdes* (2009, dir. Jessica Hausner)
*The Loved One* (1965, dir. Tony Richardson) (look out for the guided tours of 'Whispering Glades')
*Mission to Moscow* (1943, dir. Michael Curtiz) (for its Funny Putty approach to history; Hollywood whitewashes the Moscow Trials!)
*My Winnipeg* (2007, dir. Guy Maddin)
*The Nasty Girl* (1990, dir. Michael Verhoeven)
*Paradox Soldiers* (2010, dir. Oleg Pogodin) (a historic re-enactment time-slips back to what it is re-enacting to entertainingly 'justify' present-day prejudices)
*Plagues and Pleasures on the Salton Sea* (2004, dir. Chris Metzler & Jeff Springer)
*The Pleasure Garden* (1953, dir. James Broughton)
*Shooting The Past* (1999, TV movie, dir. Stephen Poliakoff)
*Tourist Trap* (1979, dir David Schmoeller)
*Westworld* (1973, dir. Michael Crichton)
*Wisconsin Death Trip* (1999, dir. James Marsh)

# Recommended reading

*Access All Areas* Ninjalicious (Toronto: Coach House Press, 2005).

*The Air Loom Gang* Mike Jay (New York: Bantam Books, 2003).

*Anticipatory History* Caitlin DeSilvey, Simon Naylor & Colin Sackett (eds.) (Axminster: Uniformbooks, 2011).

*The Black Book and Schwambrania* Lev Kassil (Moscow: Progress, 1978)

*The Delirious Museum: A Journey from the Louvre to Las Vegas* Calum Storrie (London: I.B.Tauris, 2006).

*Industrial Ruins* Tim Edensor (Oxford & New York: Berg, 2005).

*The Lonely Planet Guide To Experimental Travel* Rachael Antony & Joel Henry (Oakland: Lonely Planet Publications, 2005).

*Murders in the Winnats Pass* Mark Henderson (Stroud: Amberley, 2010).

*Relational Aesthetics* Nicolas Bourriard (Paris: Les presses du réel, 2002).

*Scarp* Nick Papadimitriou (London: Sceptre, 2012).

*Souvenirs* Michael Hughes (London: Fivefootsix, 2008).

*Vibrant Matter: A Political Ecology of Things* Jane Bennett (Durham, NC: Duke University Press, 2010).

*Welcome to Twin Peaks: An Access Guide to the Town* David Lynch & Mark Frost (New York: Pocket Books, 1991).

# Acknowledgements

I would like to thank all my fellow counter-tourists (in the hope they don't mind being so described), both real-world and virtual:

Frédéric Dufaux, Jill and Peter Parnell, Andrew Carey, Eleanor Scott Wilson, Emma Bush, Maia Messenger, Kris Darby, Jim Colquhoun, Diana Knight, Christine Duff, Penelope Dearsley, Stuart Crewes, Michael Chang, Katherine Stanley, Katie Etheridge, Anoushka Athique, Simon Persighetti, Rev. John Davies, David Overend, Cathy Turner, Stephen Hodge, Nicola Singh, Fumiaki Tanaka, Karen Smith, walkwalkwalk, Marcia Farquhar, Caroline Saunders, Ivan Cutting, Lorraine Sutherland, Siobhan Mckeown, Polly Macpherson, all the members of my research panel, and many, many more...

I would also like to thank the stewards and managers of various heritage sites who have let me play in their ruins, the University of Plymouth for funding the continuance of my indolent lifestyle while conducting this research, and most particularly my *super*visors Roberta Mock and Kevin Meethan.

# About the Author

Crab Man (Phil Smith) has claws in several different worlds.
One, large and wide, is in performance and music theatre [he
has written more than 100 plays for companies including St
Petersburg State Comedy Theatre and Opera North and he is a
founding member (1980) and the company dramaturg of TNT
(Munich)].

From site-specific performances in South Devon beach huts,
lidos, tea shops and other unconventional settings, to mis-guides
in National Trust properties, to counter-tours and drifts in city
streets, Crab Man has long practised what he preaches in this
Handbook.

He is a visiting lecturer at the University of Plymouth and at
the University of Exeter. He is also a core member of Wrights &
Sites, a group of artist-researchers who have generated a range of
mis-guides, performances, and other wonders.

See overleaf for details of other books by Crab Man and
published by Triarchy Press.

Crab Man sometimes looks like this:

Photo: Rachel Sved

225

# Also by Crab Man (Phil Smith) and published by Triarchy Press:

## Mythogeography – A Guide to Walking Sideways

*"Exeter-based performance artist Phil Smith is a veteran sideways walker and in this book develops psychogeography into mythogeography. It's a compendium of walking stories, hoaxes and digressions, lists, literary jokes, observations and dense passages of prose poetry-cum-theory."*
**Walk – Magazine of The Ramblers**

*"Footnotes, rather than remaining confined to their ghettoes, interrupt and swamp the main text, sometimes for pages at a time. The endnotes appear halfway through, and two thirds of the book is devoted to front and back matter (a joke about inflamed appendices suggests itself here). This text is dense with signposts, and... it invites diversion, digression, a kind of textual drift on the part of the reader. And of course drifting is at the heart of it. Mythogeography is cultivar or hybrid of Psychogeography... and the dérive is the basic template for many of the activities described in this book."* **an – Artists' Networks**

*"The reach is wide and deep, occasionally idiosyncratic. The fragmentary and slippery format recognises the disparate, loosely interwoven and rapidly evolving uses of walking today: as art, as exploration, as urban resistance, as activism, as an ambulatory practice of geography, as meditation, as performance, as dissident mapping, as subversion of and rejoicing in the everyday. Mythogeography is a celebration of that interweaving, its contradictions and complementarities, and a handbook for those who want to be part of it."* **Walking Home to 50**

*"This polyphonic and visually-arresting manifesto practices what it preaches, offering photographs, diagrams, taxonomies, glossaries and found texts including a 'footsteps' narrative written in the third person regarding 'The Crab Man' who walked from Manchester to Northampton looking for trees planted by Charles Hurst, the acorn-casting author of The Book of the English Oak (1911)."* **Studies in Travel Writing - Nottingham Trent University**

## A Sardine Street Box of Tricks
## by Crab Man and Signpost

This is a handbook for anyone who wants to make their own 'mis-guided' tour or walk – based on the mis-guided 'Tour of Sardine Street' that the authors created for Queen Street in Exeter during 2011.

The book is designed to help anyone who makes, or would like to make, walk-performances or variations on the guided tour. It describes a range of different approaches and tactics, and illustrates them with examples from their tour of Queen Street. For example:

- Wear something that sets you apart and gives others permission to approach you: "Excuse me, what are you supposed to be?"

- Take a can of abject booze from the street or a momentary juxtaposition of a dove and a plastic bag and mould them, through an action, into an idea

- Attend to the smallest things

- Examine the cracks in your street and the mould on its walls, note its graffiti, collect its detritus, observe how its pavements are used and abused

- Set yourself tasks that passers-by will be intrigued by: they will enjoy interrupting and even joining in with you

## Counter-Tourism: A Pocketbook
## 50 Odd Things to do in a Heritage Site (and other places)
## Assembled by Crab Man

This is a book to take with you next time you visit a historic or heritage site. Its 50 'tactics' are designed to transform the way you look at these places and to get you thinking about the way the industry packages 'heritage'. It's also an interesting and provocative present for parents, grandparents and anyone else who becomes a tourist from time to time.

CPSIA information can be obtained
at www.ICGtesting.com
Printed in the USA
LVIW010154071012

3077LVUK00010B